Then is Now

Then i

s Now

Sampling from the Past for Today's Graphics

GLOUCESTER MASSACHUSETTS

a
Handbook
for
Contemporary
Design

ROCKPORT PUBLISHERS

CHERYL DANGEL CULLEN

First published in the United States of
America by Rockport Publishers, Inc.
33 Commercial Street
Gloucester, Massachusetts 01930-5089
Telephone: (978) 282-9590
Facsimile: (978) 283-2742
www.rockpub.com

ISBN 1-56496-766-2
10 9 8 7 6 5 4 3 2 1

Printed in China.

Design and Layout: M A T T E R
Cover Image: Front cover (from left to right): Recording Industry
Association of America; Hoffmann Angelic Design; EAI; Gustavo
Machado Studio
Inside front flap: Scholz & Volkmer Intermediales Design, GmbH
Back cover (from left to right): Sagmeister Inc.; Plazm Media; Fossil; Heart
Times Coffee Cup Equals Lighting; Beattie Vass Design Pty Ltd.
Inside back flap (from left to right): Sunja Park Design; Graif Design, Inc.

acknowledgments

Special thanks to Leatrice Eiseman—unofficially color expert extraordinaire—officially, color consultant to business and industry and the Director of the Pantone Color Institute, as well as the author of several books on color and its meanings. Listening to Lee talk color is a fascinating and educating experience. I am deeply grateful for her help and willingness to share her color know-how with me.

I also owe a debt of gratitude to type historian Allan Haley, director of creative projects for Agfa Monotype, for his considerable insight and expertise. Allan graciously shared his knowledge with me and without his help, this book would be extremely lacking.

dedicated to

Rhett, who has been with me since the beginning of this project.

Contents:

"Everything old is new again."

It may be a cliché, but it has never been as true as it is today. A fondness for nostalgia and a desire to surround ourselves with things that remind of us of simpler times seems to be a coping mechanism that allows us to navigate through today's high-tech work-a-day world of electronic mail, video conferencing, never-out-of-touch telephone, fax and pager communication, and virtual reality.

Computers and the Internet may have made us more efficient, allowing us to communicate with people from around the world as if they were in our backyard, but these advances have resulted in a more impersonal society; no longer do we have the time to talk with the people in our backyard or sit on our front porch and while away the evening hours.

introduction

Experts point out that this phenomenon is what is driving the popularity of fountain pens, fine stationery, and the return to hand-written letters—letters that are keepsakes because they carry a personal touch that no E-mail correspondence can possess. They point to the growing trend in antique and collectible buying—certainly spurred on by Web enterprises such as eBay, but also ignited by a desire to recapture souvenirs of the past that we've always wanted to own or possessed once, but lost and now want to regain as souvenirs of our childhood whether they be books, furniture, or treasured toys.

The trend goes beyond collecting, to all facets of our lives. Fashions are retro; movies look back; and television has perhaps carved out the biggest niche, particularly among the baby boom generation with the popularity of retro networks such as *Nick at Nite* and *TVLand*, both of which regularly air television programs that were originally broadcast as many as fifty years ago.

Graphic designers recognize this longing—our desire to remember the past, while looking to the future—and are sharing its positive associations with their clients. The past can communicate trust, goodwill, honesty, neighborliness, and family values—Mayberryesque characteristics that are desired and at least theoretically, aspired to by everyone.

But when recreating the past, exactly where do you start? What makes a design hearken back to an earlier era? Sepia photographs and a handwritten script may evoke the 1900s, but they cannot recreate the atmosphere of early twentieth century alone. The color palette, the events of the day—those in the headlines as well as those making news in science and technology, art, architecture, entertainment, and popular culture—all influence graphic design.

Then is Now—Sampling from the Past for Today's Graphics is a time capsule in miniature. Here, you'll find information on each decade of the twentieth century and what made them look the way they did. The colors that were popular in the day and why they were popular are discussed in the Color Cues section of each chapter where Leatrice Eiseman, director of the Pantone Color Institute and color consultant, graciously lent her expertise. Noted are when new colors made their debut—for using a color before it was created is one sure way to sabotage even the finest retro design. Typefaces get the same analysis in each chapter's Type Tracker. Allan Haley, director of creative projects at Agfa Monotype, contributed his insight into type history, which is provided in a decade-by-decade overview of the typefaces that were invented and used during each period, as well as those indigenous to the era that are particularly evocative of its style.

In all, *Then is Now—Sampling from the Past for Today's Graphics* is like *Back to the Future's DeLorean*—a time-travel vehicle that breaks through the current time and space continuum. Enjoy the trip.

A CLOSER LOOK

100
OF KODAK
Years

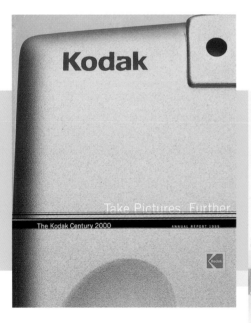

Kodak

Take Pictures. Further.

The Kodak Century 2000 ANNUAL REPORT 1999

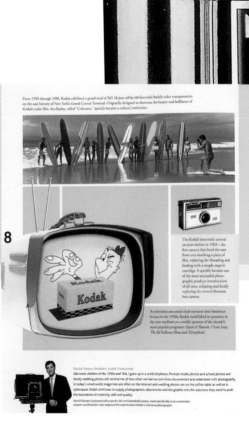

NEW YORK

From 1950 through 1990, Kodak exhibited a grand total of 565 18-foot-tall by 60-foot-wide backlit color transparencies on the east balcony of New York's Grand Central Terminal. Originally designed to showcase the beauty and brilliance of Kodak's color film, the display, called "Colorama," quickly became a cultural institution.

The Kodak Instamatic arrived on store shelves in 1963 — the first camera that freed the user from ever touching a piece of film, replacing the threading and loading with a simple snap-in cartridge. It quickly became one of the most successful photographic product introductions of all time, eclipsing and finally replacing the revered Brownie box camera.

As television sets made their entrance into American homes in the 1950s, Kodak established its presence in the new medium as a weekly sponsor of the decade's most popular programs: Ozzie & Harriet, I Love Lucy, The Ed Sullivan Show and Disneyland.

8

Patrick Siewert, President, Kodak Professional
Like most children of the 1950s and '60s, I grew up in a world of photos. Portrait studio photos and school photos and family wedding photos still remind me of how often we had our own lives documented and celebrated with photography. In today's wired world, magazines are often on the Internet and wedding photos are on the coffee table as well as in cyberspace. Kodak continues to supply photographers, laboratories and the graphic arts the solutions they need to push the boundaries of creativity, skill and quality.

Patrick Siewert is pictured with a rare 8 x 20-inch Deardorff camera, made specifically to accommodate custom-cut Ektacolor color negative film used to shoot Kodak's Colorama photographs.

7

Although Kodak had been in the microfilm business since 1927, wartime required a new approach to this time-tested technology. Kodak developed a way to easily print the 16mm microfilm onto 4-by-5-inch hard-copy prints, and a new communications medium, dubbed "V—Mail" was born. Although not quite as fast and efficient as the "e-mail" it anticipated, V—Mail helped send nearly half a billion messages between soldiers and their families.

Candy Obourn is helping people manage business documents since 1988, when our first microfilm machines were manufactured by the 1860s, Kodak microfilmers could copy an amazing – by mid-century standards – 500 sheets per minute. In 1999 we entered the Guinness Book of World Records when a Kodak Digital Science Scanner digitized nearly 1.7 million documents in 24 hours!

Candy Obourn is holding a 1940 Kodak 3E, used extensively by wartime photojournalists and military photographers.

Eastman Kodak, the famed manufacturer of the camera, commemorates 100 years in its 1999 annual report that traces the changing face of Kodak and photographic technology. It all began in the late 1890s with, what was called, The Ordinary Kodak. From there, we got to know the Kodak Brownie, selling originally for one dollar; its simple operation was promoted with a cherub-faced graphic icon. As the years progressed, Kodak's image changed to include the frequent appearances of "The Kodak Girl" in the early part of the century, followed by a Mickey Mouse-themed version of the Brownie. While its advertising always retained the familiar yellow and red logo, the imagery kept pace with a changing consumer lifestyle—promoting the simple fact that "Christmas is Colorful" to spotlight the introduction of color film to educating the public about how Kodak created V-Mail during World War II.

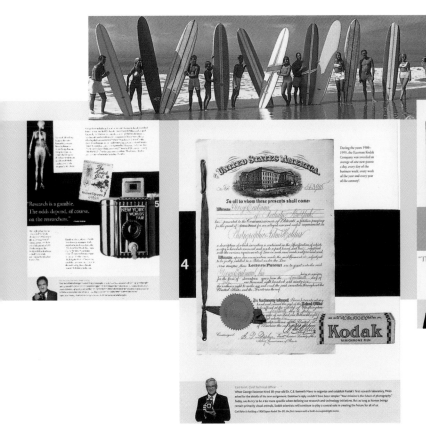

PROJECT: The Kodak Century
1900-1999 Annual Report
CLIENT: Eastman Kodak
DESIGN FIRM: Addison
ART DIRECTORS: David Kohler, Reid Hamilton
DESIGNERS: Reid Hamilton, Allison Sadler
PHOTOGRAPHER: Timothy Archibald
COPYWRITER: Paul Goldman
PRINTER: Avanti Case-Hoyt

PROJECT: The Big Event Poster
and Identity Materials
CLIENT: Julie Line and
Bob Neumann Photography
DESIGN FIRM: Palazzolo Design Studio
ART DIRECTOR: Gregg Palazzolo
DESIGNERS: Gregg Palazzolo,
Troy Gough, Brad Hineline
PRINTER: Etheridge

THE **BIG EVENT**

A MOVING EXTRAVAGANZA

Featuring

NEUMANN PHOTOGRAPHY

In Conjunction With~

LINEPHOTOGRAPHY

New TO THE RING: DEAN VANDIS PHOTOGRAPHER

And a Cast of Sidekicks

'SIZZLIN SALLY' 'BABS & PETEY' THE AMAZING POOCH's 'BIG TOP' BRIAN BABY 'ARMSTRONG'

Our New Location

312 ELLSWORTH GRAND RAPIDS MICHIGAN 49503

PHONE 616.454.1001 FACSIMILE 616.454.4546

BROUGHT TO YOU BY NEULINE PRODUCTIONS

the 1900s

The first two decades of the twentieth century were turbulent years, full of change. At the beginning, the world was at peace, but not even twenty years later, it had seen the devastation of a World War. Technology boomed.

Following on the heels of the Industrial Revolution of the late-nineteenth century, the world saw some of the most ingenious inventions and advancements that have brought us to where we are today: increased travel by ocean liner, the advent of the automobile, as well as air flight. But sometimes, success breeds overconfidence and by the 1920s, the world had experienced disasters that claimed numerous lives and shook our confidence to its core.

In the early years of the century, women were still garbed in long dresses and corsets, hair piled high on their heads, in the style of the Gibson girl. But just twenty years later, they had won the right to vote and raised their skirts and cut off their hair. It was an era of change.

head lines OF THE EARLY 1900s

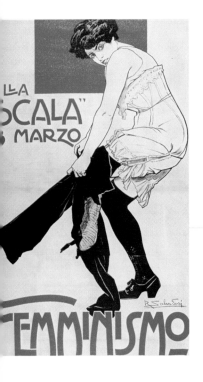

On April 18, 1906 an earthquake and subsequently, fires tore through San Francisco, California, virtually destroying the city. Yet another disaster made headlines on April 15, 1912, when the presumably unsinkable *Titanic* hit an iceberg and foundered on her maiden voyage with a loss of 1513 lives.

World War I began May 28, 1914 and ended four years later on November 11, 1918. Russia was experiencing its own internal strife and its bloody revolution began March 4, 1917.

Amid all the war and turmoil, suffragettes were fighting for a woman's right to vote and on February 5, 1918 a British Act of Parliament granted votes for women—aged 30 and over.

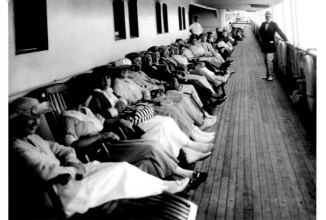

entertainment

Music-hall style of entertainment, popular since the mid-nineteenth century, continued to draw the crowds, featuring variety shows including singers, comic acts, and acrobats.

The foxtrot was a fashionable dance in 1913.

People with money, and those who scrimped and saved, enjoyed travel more than ever before and took to the great ocean liners that crossed the Atlantic in droves.

In 1917, women cut their hair—they "bobbed" it—and the "bobbed" hairstyle became the fashion statement that also signified freedom for many women.

art
and architecture

Fauves, translated to mean "wild beasts," a group of Parisian painters of the early 1900s including such artists as Dufy, Matisse, Rouault, Vlaminck, shocked the critics by their brilliant use of color. The trend became known as the Fauvist art movement.

An Italian artistic movement, Futurism (1905-1915) became popular. Characterized by painters using cubist forms and strong colors, Futurism emphasized violence, machinery and politics, and went against traditional thinking and culture, and the Romantic Movement.

Imagism, a school of poetry of the early 1900s, concerned with precise language, direct treatment, and freedom of form, arose as did Orphism, a French abstract movement founded in 1912 by Delaunay, among others. It was later called Simultaneism.

Picasso's "blue" period ran from 1901 through 1904.

In 1907, the world saw the first Cubist paintings, a movement in modern French painting started by Picasso and Braque that presented objects as basic shapes of cubes, spheres, cylinders, and cones.

Following the Impressionism movement, which ended around 1905, Post-Impressionism took hold, giving artists such as Cèzanne, Gauguin, van Gogh, Renoir, and Degas, free right to experiment with expression, form, and design. No longer did nature and objects have to be represented realistically.

technology and science

It was the age of flight marked by the first zeppelin to make a trial flight July 2, 1900 and by Orville and Wilbur Wright, who made the world's first flight by a heavier-than-air machine on December 17, 1903 at Kitty Hawk, North Carolina. Across "The Pond," Blériot made the first cross-channel flight in a heavier-than-air machine July 25, 1909.

While some set their sights on the sky, others went underground and in November 1904, New York City's subway (underground railway) opened in New York. Meanwhile, in 1909 Henry Ford began "assembly line" production of cheap motorcars, producing the Model T.

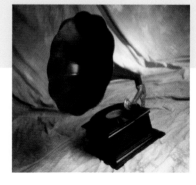

On December 16, 1915, Albert Einstein published his General Theory of Relativity.

In the early part of the century, women were getting their first taste of emancipation, and though it didn't last long, it did have an influence on color—primarily as evidenced by female undergarments. Lingerie began showing up in opalized pinks (PANTONE 5035) and pale pinky-beige tones (PANTONE 4675), marking the beginning of romantic, sexy colors used in underwear fashions, which had previously been seen as purely utilitarian. Women began using cosmetics, too, and the first blushes of rouge became popular. Face powders took on a tint for the first time and were available in a variety of colors to match complexions.

Color Cues: 1900s

Until the beginning of World War I in 1914, light colors were popular—light green (PANTONE 454), pale blue (PANTONE 5445), and what was called "swooning" mauve (PANTONE 5015). During this time, colors were often differentiated as city colors and the more utilitarian country colors, which included a lot of brown and tan (PANTONE 465).

The Art Nouveau movement had a tremendous influence on color and iridescence, as did the invention of the electric light bulb. Simply put, color usage changed because electric lights illuminated color and one could see it better than under gas light.

There was a bright explosion of color brought on by the popularity of the Ballet Russe. Similarly, the Fauvists—using shades of scarlet (PANTONE 199) and apple green (PANTONE 584) caused a color explosion of their own. The Impressionists and Neo-Impressionists indulged in floral hues of yellow (PANTONE 128), orange (PANTONE 143), teal (PANTONE 321), periwinkle (PANTONE 660), violet (PANTONE 512), rust (PANTONE 704), and of course, green (PANTONE 575), which ultimately influenced the colors of interior design and clothing for the wealthy.

During the war, color all but disappeared. Colorful clothing still existed, but it was difficult to obtain and was available only if one was willing to pay the hefty prices.

1900s

Type
Tracker:

Influences

Aside from the Arts & Crafts movement, many fonts were influenced by hand-lettered creations that printers brought to type foundries in the hopes that they could be replicated as new typestyles. Sheet music of the period included a lot of hand-lettering that influenced type design considerably and is a great source of inspiration for mimicking the faces that were popular during the time, as in vintage advertising.

Characteristics

During the late 1800s, typefaces were known for their circus-like appearance. They were very elaborate and ornate, which was perfect for the Big Top. The first designs released after the turn-of-the-century were distinctive for their simplicity, which had a calming effect on type. These faces were influenced somewhat by the Arts & Crafts movement and had a hand-hewn appearance, in fact, many were designed to look as if they had been lettered by hand.

Fonts of the early 1900s

Unfortunately, many of the distinctive display faces of this period are not available in digital type, but can be found in old type books for reference. (One good source to try is *American Metal Typefaces of the Twentieth Century* by Mac McGrew and published by Oak Knoll Books, New Castle, Delaware, 1993.) The most characteristic fonts of the period include Clearface Gothic (ITC revitalized this face as ITC Clearface, but it isn't an exact replica of the original typeface), Florentine, Roycroft, Pabst, Bullfinch, Della Robbia, and Globe Gothic.

The fonts created during this time that are still widely used today have become almost generic in their appearance, and while born in the early twentieth century, they do not necessarily evoke that era. Nevertheless, these text and display fonts, such as News Gothic, Franklin Gothic, and others, along with their familial variations, are historically accurate to the time and are considered by many to be the bread and butter fonts of today.

Typefaces owned and provided by Agfa Monotype.

Fonts you probably own that evoke the era:

Franklin Gothic
abcdefghijklmnopqrstuvwxyz1234567890
ABCDEFGHIJKLMNOPQRSTUVWXYZ

Franklin Gothic Extra Condensed
abcdefghijklmnopqrstuvwxyz1234567890
ABCDEFGHIJKLMNOPQRSTUVWXYZ

Franklin Gothic No. 2
abcdefghijklmnopqrstuvwxyz1234567890
ABCDEFGHIJKLMNOPQRSTUVWXYZ

Bodoni
abcdefghijklmnopqrstuvwxyz1234567890
ABCDEFGHIJKLMNOPQRSTUVWXYZ

Bodoni Poster Italic
abcdefghijklmnopqrstuvwxyz1234567890
ABCDEFGHIJKLMNOPQRSTUVWXYZ

Caslon
abcdefghijklmnopqrstuvwxyz1234567890
ABCDEFGHIJKLMNOPQRSTUVWXYZ

Caslon Italic
abcdefghijklmnopqrstuvwxyz1234567890
ABCDEFGHIJKLMNOPQRSTUVWXYZ

CONTEMPORARY
design
looks back

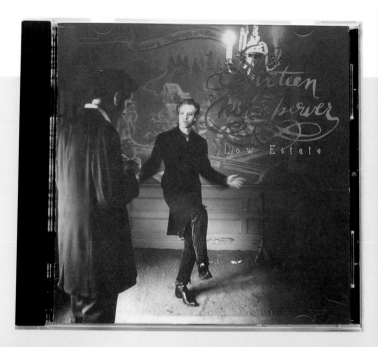

Sixteen Horsepower, a band whose music is heavily
influenced by early Americana, receives a fitting tribute
in the artwork for its *Sackcloth 'n' Ashes* CD. Designer
Sunja Park used typography that emulates the newspapers
and broadsides of the day on the cover art as well as
throughout the inside pages of the insert—which sport a
decidedly American western influence as well. The
sepia-toned photograph further reinforces the authen-
ticity of the 1900s design, while Park stained the pages
to further emphasize the feeling of antiquity.

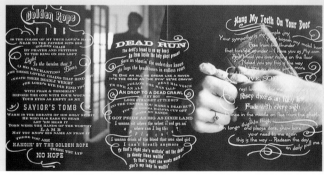

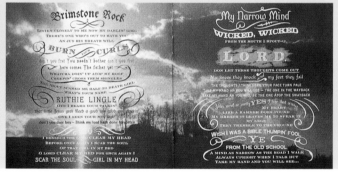

PROJECT: Sixteen Horsepower-
Low Estate CD

CLIENT: A & M Records

DESIGN FIRM: Sunja Park Design

ART DIRECTOR/DESIGNER: Sunja Park

PHOTOGRAPHER: Ken Schles

TYPOGRAPHY: Sunja Park

PRINTER: AGI

OPPOSITE PAGE

PROJECT: Sixteen Horsepower-
Sackcloth 'n' Ashes CD

CLIENT: A & M Records

DESIGN FIRM: Sunja Park Design

ART DIRECTOR/DESIGNER: Sunja Park

PHOTOGRAPHER: Keith Carter

TYPOGRAPHY: Sunja Park

PRINTER: AGI

"The flourish-y, dark aesthetic fit," said designer Sunja Park of the CD artwork for Sixteen Horsepower's *Low Estate* CD with a 1900s authenticity. Because the band is particularly influenced by early Americana, Park created his own typography, emulating songbooks, Bibles, and broadsides of the time—which used a variety of typestyles in contrast to today's rules of simplicity in type—to achieve historical accuracy. The photography also hearkens back to a simpler time, where the clothing as well as the imagery portrayed—whittling and the Bible—conjure up images of the early twentieth century.

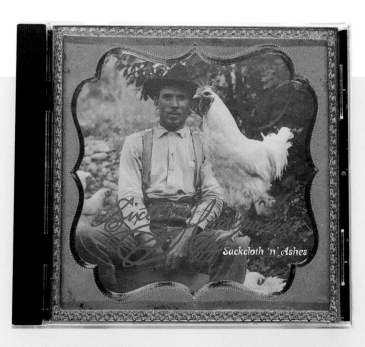

What period has most influenced your personal style of design?

"All of them really. I love everything, especially if it's obscure. Although, I guess it's mostly American and European design."

— *Sunja Park, Sunja Park Design, who looks for graphic inspiration in thrift shops and flea markets*

"No other style would have been appropriate," said John Sayles of the Arts and Crafts-inspired logo and letterhead he created for the 1999 Arts and Crafts Conference held at the Hotel Pattee, a tribute to the Arts and Crafts movement in architecture and interior design. Striving for authenticity, Sayles used bold lines and blocks of highly saturated color to replicate the appearance of stained glass, characteristic of Arts and Crafts interiors.

PROJECT: Arts & Crafts Conference
Logo and Letterhead
CLIENT: Pattee Enterprises
DESIGN FIRM: Sayles Graphic Design
ART DIRECTOR/DESIGNER/ILLUSTRATOR: John Sayles

The Hotel Pattee was built in 1913 in Perry, Iowa and restored in the late 1990s in its true American Arts and Crafts style. In keeping with its architecture, Sayles Graphic Design created matching collateral materials that convey the Arts and Crafts period. Using textured materials, strong lines, and jewel-tone colors (found in the hotel), John Sayles created a guest book that is consistent and authentic to the period. The book uses brown leather accented with red, green, and dark yellow. An embossed copper plate is affixed to the cover and the binder is lined with actual wallpaper from the hotel's lobby.

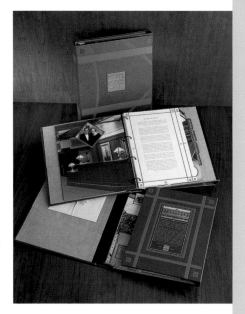

PROJECT: Hotel Pattee Guest Directory
CLIENT: Sayles Graphic Design
ART DIRECTOR/DESIGNER: John Sayles
PHOTOGRAPHER: John Clark

To commemorate Jester Insurance's centennial, Sayles Graphic Design accessed a wealth of archival information and chose to feature a style of design prominent at the time of the company's founding. John Sayles used natural materials—a suede binding—and accented the cover with a custom logo resembling a woodcut image. Vintage photos and an old script typeface complete the look. As a finishing touch, the brochure was inserted into an old-style policy envelope.

PROJECT: Jester Insurance
Centennial Brochure
CLIENT: Jester Insurance
DESIGN FIRM: Sayles Graphic Design
ART DIRECTOR/DESIGNER: John Sayles
COPYWRITER: Diane De Vault

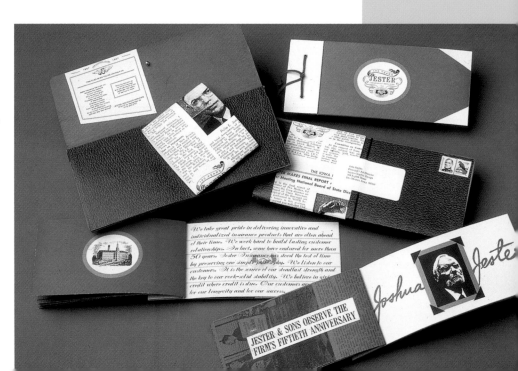

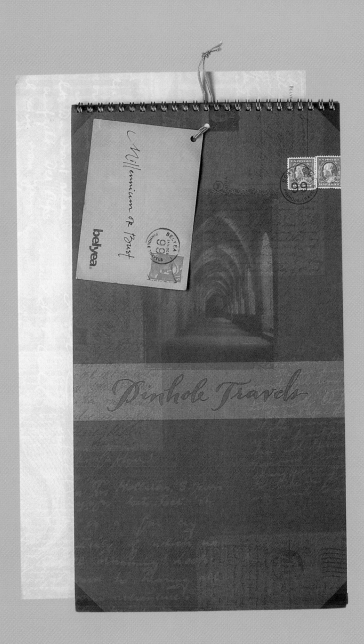

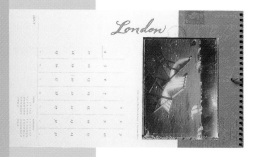

PROJECT: Pinhole Travels Calendar

CLIENT: Belyea

DESIGN FIRM: Belyea

ART DIRECTOR: Patricia Belyea

DESIGNER: Ron Lars Hansen

PHOTOGRAPHER: Rosanne Olson

COPYWRITERS: Liz Holland, Rosanne Olson

PARTNERS: ColorGraphics, Rosanne Olson, Iridio

The tagline, "Millennium or Bust," on this self-promotional calendar from Belyea applies to December 1999, but here it feels as though the message is designed to welcome in the year 1900, not 2000. However, even that is a misnomer as the intent was to create a piece that appears timeless. "The subjects of the photos make the places seem timeless—no cars, no people," said Patricia Belyea, who "wanted to emphasize that timelessness and the era of elegant travel was a great style."

Photographer Rosanne Olson worked with a pinhole camera, hence of the name of the piece, using long-range exposures from several seconds to more than ten minutes. The photos, taken in present day, do indeed appear timeless. Many shots are of ruins, architectural sites, and park settings, which appear decidedly lost in time. The main typography was done by a professional calligrapher, who copied screened back type that was scanned from actual postcards sent from the places in the photos in the 1800s and early 1900s. For that added feeling of authenticity, Belyea soaked the tag card in tea and handwrote the message: Millennium or Bust.

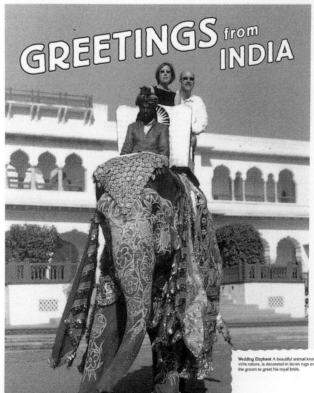

PROJECT: Greetings from India
Save-the-Date Postcard
CLIENT: Kay Schultz
DESIGN FIRM: Anvil Graphic Design
ART DIRECTOR: Laura Bauer
DESIGNER: Lori Rosales
PHOTOGRAPHER/STYLIST: Kay Schultz
CALLIGRAPHER: Molly Coffin

This unique save-the-date postcard announces the photographer's upcoming nuptials. Designers wanted to mimic the look of antique European postcards and to do so, used a photo of an elaborately adorned elephant, carrying the couple. They treated the photo as a duotone and embellished it with typography, indicative of the simple typestyles used on vintage postcards. An antique stamp, calligraphy, deckle edging, and a special postmark are the extra details that add to its authenticity, not to mention, its attention-getting value. The card wasn't mailed as is; it arrived to the recipient enclosed in an outer envelope.

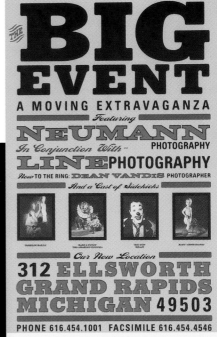

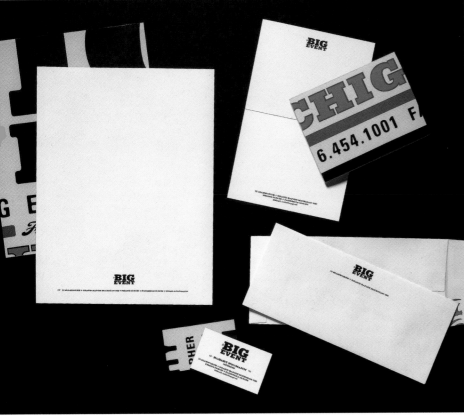

PROJECT: The Big Event Poster
and Identity Materials
CLIENT: Julie Line and Bob Neumann
Photography
DESIGN FIRM: Palazzolo Design Studio
ART DIRECTOR: Gregg Palazzolo
DESIGNERS: Gregg Palazzolo, Troy Gough,
Brad Hineline
PRINTER: Etheridge

Photographers Julie Line and Bob Neumann were opening a new studio with
the name - Big Event. When they needed an identity, Michigan's Palazzolo
Design Studio came to the rescue with a poster and collateral package themed to
the aesthetics of early century circus design. "The name, Big Event, pushed the
design in recreating the feel of an old circus poster with a contemporary flair,"
said Gregg Palazzolo. Using typography that represented the old woodcut type
of the period and a color palette consistent with posters advertising traveling
circuses, Palazzolo created a big event of his own. The poster was mailed to
prospective area clientele, announcing the new photo studio, and the identity,
using the same artwork, kept the theme alive, while also being cost-efficient.

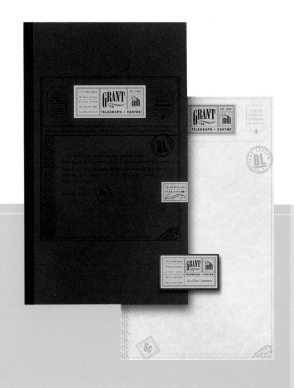

PROJECT: Grant Telegraph Stationery
CLIENT: Grant Telegraph
DESIGN FIRM: Greteman Group
CREATIVE DIRECTOR: Sonia Greteman
ART DIRECTORS: Sonia Greteman,
James Strange
DESIGNER/ILLUSTRATOR: James Strange
COPYWRITER: Deanna Harms

The goal was to create a low-cost, attention-getting letterhead package for Grant Telegraph, an objective that was met by using MACtac StarLiner brown kraft pressure sensitive labels as an integral part of the design. Designers applied the label paper as a tip-on label to the letterhead, presentation folder, and business card, adding texture to each piece—"similar to the messages once sent by this former telegraph station," said Sonia Greteman, while keeping costs to a minimum. "Another cost-saving solution was found by creating the business cards from discarded presentation folders."

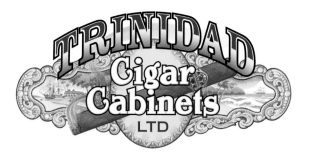

Cigar smoking was a gentleman's pastime in the early 1900s and cigar packaging and labeling was opulent. The rich color palette and intricate type was designed to be eye-catching and indicative of the cigar's quality and long-standing tradition. The parallels between cigar labels of old and The Trinidad Cigar Cabinet Company, maker of quality cigar cabinets, were obvious. So was the choice to recreate the vintage cigar packaging for an upscale product of today.

PROJECT: Trinidad Cigar Cabinets Ltd. Logo
CLIENT: The Ken Roberts Company
DESIGN FIRM: Shields Design
ART DIRECTOR/DESIGNER: Charles Shields
ILLUSTRATOR: Doug Hansen

What period has most influenced your personal style of design?

"...the early part of the twentieth century—the 1920s through 1940s. I have great affection for the pictorial representation of products and services that were popular in American commercial design throughout this period and the optimistic, sometimes naïve, voice with which they spoke. Rather than being influenced by a particular person or event, I feel that I am most indebted to the often nameless graphic artists of the early century who strove to bring beauty and personality to even the most mundane of products like nuts and bolts, hair nets, and laundry soap."
—*John J. Moes, Studio Flux*

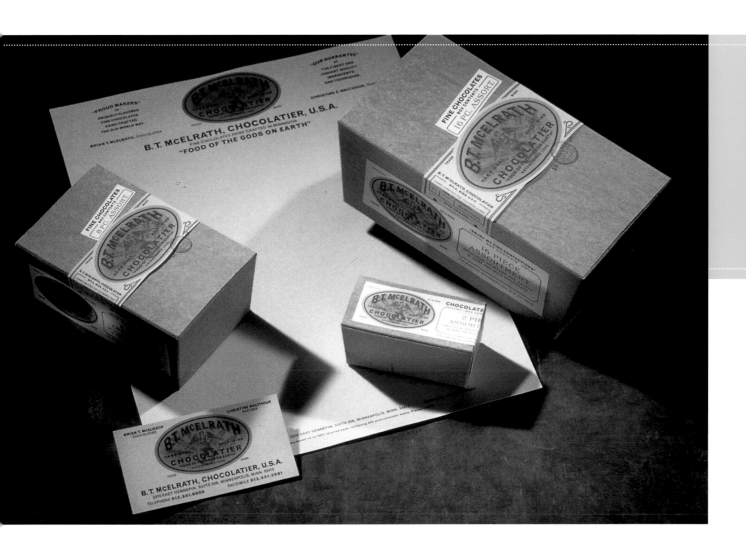

Instead of going with the traditional color palette used in chocolate packaging—brown, gold, and red—Studio Flux felt that the packaging for its client, B.T. McElrath Chocolatier, maker of handcrafted old-world style truffles, should reflect the lushness of the packaging found in the last decade of the 1800s and the early years of the 1900s. The result is a brown kraft box with a distinctive multi-hued green identity embellished with a series of white labels and custom accouterments.

PROJECT: B.T. McElrath Chocolatier Chocolate Packaging
CLIENT: B.T. McElrath
DESIGN FIRM: Studio Flux
ART DIRECTOR: John J. Moes
DESIGNERS: John J. Moes, Holly A. Utech
ILLUSTRATORS: John J. Moes, Ken Jacobsen
PRINTER: Fast Print

Engraved artwork, showing fine detail in line work and sketches, was widely used in the early to mid-century. This logo for Faith and The City is a highly detailed engraving, which is balanced by the use of small capitals to create the feeling of a classic early century logo that visually references stock certificates, educational diplomas, and government documents. Engraving, by its very nature, lends an air of importance and elegance to graphic designs.

PROJECT: Faith and The City Identity

CLIENT: Faith and The City

DESIGN FIRM: EAI

CREATIVE DIRECTOR: Matt Rollins

DESIGNER: Courtney Garvin

ILLUSTRATOR: Clancy Gibson

FAITH AND THE CITY

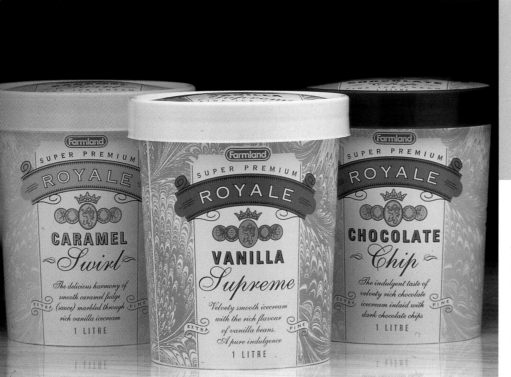

PROJECT: Farmland Royale Super Premium Ice Cream Packaging

CLIENT: Coles Myer Ltd.

DESIGN FIRM: CPd - Chris Perks Design

ART DIRECTOR/DESIGNER: Chris Perks

FINISHED ART: Neil Moorhouse

To emphasize the premium qualities of Farmland Royale Super Premium Ice Cream, Australian designer Chris Perks sought inspiration in Parisian style and architecture of the early century to create imagery that "reflects traditional European indulgence." This era is actualized through the packaging's sans serif and script typefaces, embellished with gold, and the feathered marble background pattern. In all, it creates a premium package design that invites indulgence.

PROJECT: Covent Garden Logo
and Product Packaging
CLIENT: Ross Cosmetics
DESIGN FIRM: CPd – Chris Perks Design
ART DIRECTOR/DESIGNER: Chris Perks

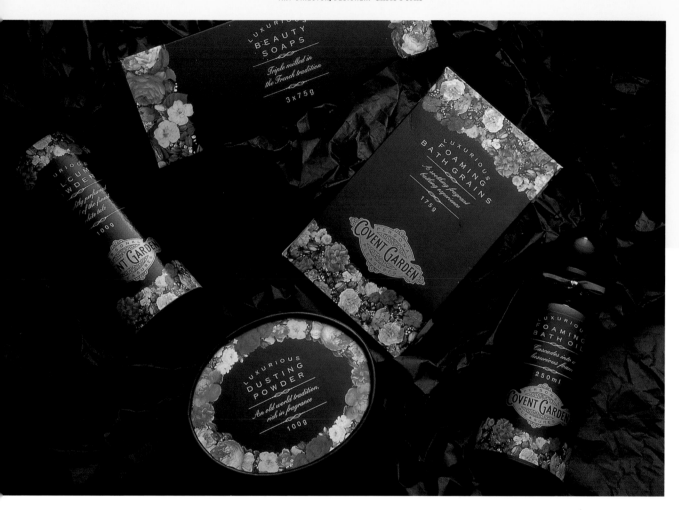

Covent Garden, a line of bathroom products, gets the Victorian treatment in its logotype and packaging, a style that was still prevalent at the turn of the century when Covent Garden, a flower market in London, enjoyed its heyday. "The brand logotype is overtly Victorian in shape, typography, embellishments, and color," said Chris Perks of Australia's Chris Perks Design, citing that the product descriptions use the typestyles and decorative rules from the period, evocative of "Victorian splendor," adds Perks. The color palette is vivid with floral hues in keeping with the garden theme as well as the popular colors of the day.

ART MOVEMENTS
of the
20th
Century

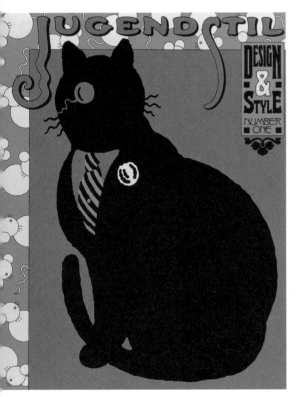

Jugendstil, an artistic movement that debuted in Germany in the mid-1890s and continued through the early 1900s, gets its name from the German word for youth, Jugend. The movement is characterized by its early years—before 1900—that were based on floral motifs, reflecting English Art Nouveau and Japanese applied arts and prints, and its post-1900 phase that is marked by its abstract look.

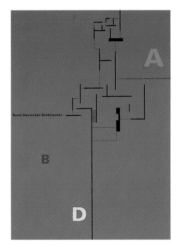

This architectural poster uses a traditional Bauhaus color palette of yellow, red, and blue.

PROJECT: BDA Poster
CLIENT: BDA
(Association of German Architects)
DESIGN FIRM: Baumann & Baumann,
Büro für Gestaltung
ART DIRECTORS/DESIGNERS/ILLUSTRATORS:
Gerg Baumann, Barbara Baumann
PRINTER: Paul Seils

PROJECT: *Design & Style* Jugendstil
Publication Cover
DESIGN FIRM: The Pushpin Group Inc.
DESIGNER/ILLUSTRATOR: Seymour Chwast
EDITOR: Steven Heller

The Bauhaus movement, also known as Staatliches Bauhaus, was a school of design, architecture, and applied arts that existed in Germany from 1919 until 1933. It derived its name, Bauhaus, meaning "house of building," from inverting the German word Hausbau, which means "building of a house," and strived to train students equally in art and craftsmanship. Here, are three interpretations of the Bauhaus style:

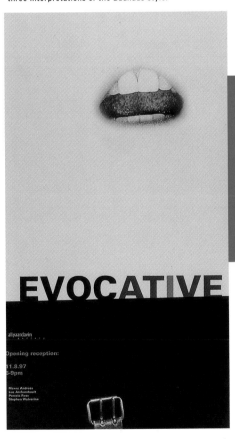

The Pushpin Group Inc.'s Bauhaus-inspired cover from *Design & Style*.

PROJECT: *Design & Style* Bauhaus Publication Cover
DESIGN FIRM: The Pushpin Group Inc.
DESIGNER: Seymour Chwast
EDITOR: Steven Heller

Evocative, an art gallery poster was designed in the Bauhaus style because of its "no-nonsense, formal, and logical design structure," said designer Anne-Davnes Dusenberry of The Partnership. "This grid allowed me to say what I needed to say quickly, painlessly and with the purest of vision. The idea behind Bauhaus is that it frees you up from having to decorate or embellish."

Type, color, and geometric images are characteristic of the De Stijl aesthetic, which originated among a group of Dutch artists in Amsterdam in 1917 and remained popular through the early 1930s. The movement influenced painting, decorative arts, typography, and architecture.

PROJECT: *Design & Style* De Stijl Publication Cover
DESIGN FIRM: The Pushpin Group Inc.
DESIGNER/ILLUSTRATOR: Seymour Chwast
EDITOR: Steven Heller

PROJECT: Evocative Poster
CLIENT: Aliya Adavin Gallery
DESIGN FIRM: The Partnership
ART DIRECTOR: David Arnold
DESIGNER/ILLUSTRATOR: Anne-Davnes Dusenberry
PRINTER: ACI

A CLOSER LOOK

ART MOVEMENTS
of the
20th Century

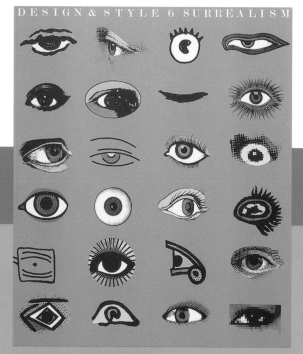

Casting aside traditional images of art, Futurism, 1909-1930 was born. The style sought to emphasize the motional involvement of modern life and called for imagery that rendered the perception of movement and communicating the sensation of speed and change. To accomplish this, many proponents of the Futurist movement adopted the Cubist technique of depicting several sides and views of an object simultaneously by fragmenting and re-interpreting plane surfaces and lines. The result is often brighter and more vibrant than cubist works and reveals dynamic, often agitated imagery.

Surrealism, an outgrowth of the Dada, 1917-1940, movement, was popular in art and literature between World Wars I and II. Its design style is characterized by images created to evoke psychic responses with an emphasis on content and free form. Here, the numerous variations of the human eye prompt an eerie, unsettling response in the viewer, perfectly in keeping with the Surrealistic style.

PROJECT: *Design & Style* Futurism
Publication Cover
DESIGN FIRM: The Pushpin Group Inc.
DESIGNER/ILLUSTRATOR: Seymour Chwast
EDITOR: Steven Heller

PROJECT: *Design & Style* Surrealism
Publication Cover
DESIGN FIRM: The Pushpin Group Inc.
DESIGNER/ILLUSTRATOR: Seymour Chwast
EDITOR: Steven Heller

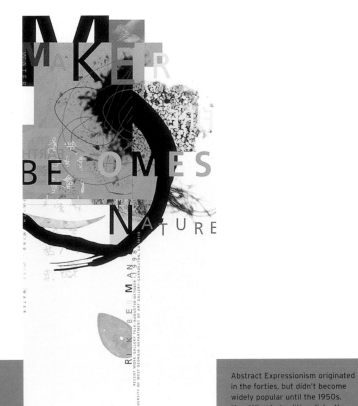

As a style, perhaps Streamline is the most evocative of a specific decade. Everything about its sleek, clean lines and no-frills typestyle characterize the elegant style of the 1930s–a look that is replicated most notably in the architecture, including New York's Empire State Building, constructed during the thirties in record time as a means to provide work to unemployed construction workers.

Abstract Expressionism originated in the forties, but didn't become widely popular until the 1950s. Unsettling to traditionalists, the movement typically doesn't represent specific subject matter, but is created by applying color rapidly to a blank canvas and allowing one's spontaneity and creativity direct its placement. Sometimes paint was applied with large brushes, while it was also often dripped or thrown onto the canvas.

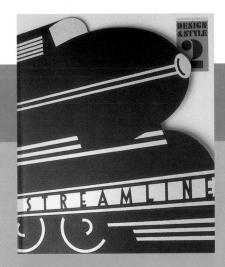

PROJECT: *Design & Style* Streamline Publication Cover
DESIGN FIRM: The Pushpin Group Inc.
DESIGNER/ILLUSTRATOR: Seymour Chwast
EDITOR: Steven Heller

PROJECT: Maker Becomes Nature Poster
CLIENT: Aliya Ardavin Gallery
DESIGN FIRM: The Partnership
ART DIRECTOR: David Arnold
DESIGNER/ILLUSTRATOR: Anne-Davnes Dusenberry
PRINTER: ACI

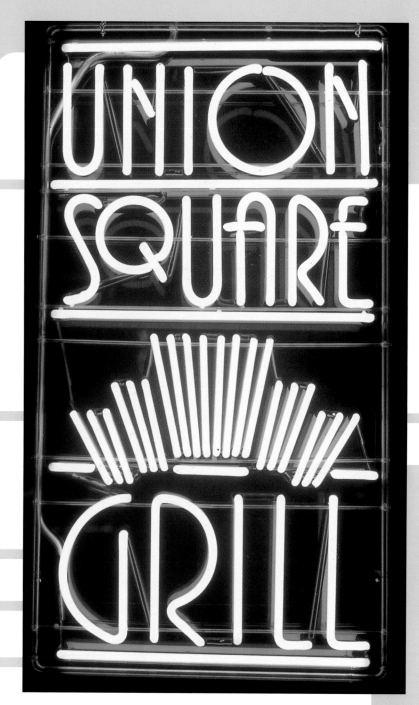

PROJECT: Union Square Grill
Logo and Neon Signage
CLIENT: Union Square Grill
DESIGN FIRM: Hornall Anderson
Design Works, Inc.
ART DIRECTOR: Jack Anderson
DESIGNERS: Jack Anderson,
Mary Hermes, David Bates
ILLUSTRATOR: David Bates

the 1920s

The ten years between 1919 and 1930 were called the Roaring Twenties, The Jazz Age. Times were good. The war was over and prosperity reigned. Women started wearing make-up, skirts rose to the knee and above. Good girls from good families turned to the "flapper" lifestyle, known for their ostentatious, unconventional dress and habits that scorned tradition.

The cocktail was invented and after enjoying a drink (albeit often covertly since prohibition reigned in the U.S. from 1920 until 1933), entertainment was plentiful. Men would frequent burlesque shows and couples would dance—most notably, such scandalous dances as the Charleston.

In the U.S., this party-atmosphere, characterized by innovative music and dances, a new feminism, and an easing of the Victorian standards of dress and conduct, stood in direct opposition to the 18th Amendment, which prohibited the manufacture, transportation, and sale of alcoholic beverages. Thus began the battle between those determined to enforce the new law and thereby stamp out vice and

uphold morals—the "drys"—and those who felt the 18th Amendment curtailed their individual rights and freedoms —"the wets."

F. Scott Fitzgerald perhaps best illustrated the lifestyle of the 1920s' carefree, nouveau rich in his book, *The Great Gatsby*. But just as his novel does not offer a happy ending, neither did this decade. Just three months before the close of the 1920s, the New York stock market collapsed and the world was plummeted into the middle of an economic crisis of global proportions.

head lines OF THE 1920s

The U.S. ratified the 18th Amendment to its Constitution, which prohibited the manufacture, transportation, and sale of alcoholic beverages in the United States, ushering in the Prohibition Era, which ran January 29, 1920 through December 5, 1933.

May 7, 1928—Britain reduces the age for women voters from 30 to 21.

On November 3, 1928, Turkey abolishes the use of the Arabic alphabet, and adopts the Roman alphabet.

On Valentine's Day, February 14, 1929, six notorious Chicago gangsters are machine-gunned to death in a warehouse by a rival gang. The bloody killing became known as the St. Valentine's Day massacre.

October 28, 1929 was referred to as "Black Friday," following the crash of the U.S. Stock Exchange in New York, an event that threw the world into an economic crisis, known as the Great Depression.

entertainment

The twenties saw the "birth of the blues," a form of jazz known for its slow, sad intonations, as well as ragtime music (piano music based on a rigidly syncopated pattern) and reggae.

art
and architecture

Burlesque shows became the rage in entertainment for male audiences because of the off-color, often vulgar tone to performances.

Pioneered by Kandinsky, Abstract Art, an artistic movement that uses geometric and other designs instead of realistic forms to represent ideas, makes inroads in the art world. Meanwhile, Abstract Expressionism, pioneered by Jackson Pollack, a combination of abstract art and expressionism, characterized primarily by dripping and smearing paint at random, also takes hold of the imagination. Action painting became popular—a type of abstract expressionism.

In 1922, the American cocktail, a mixed alcoholic beverage, became popular. Two years later, in 1924, Mah-jongg, a Chinese board game, became a world craze. Then, in 1925, people took to their feet for entertainment when the dance known as the Charleston becomes fashionable.

The first public sound-on-film performance is shown at the Rialto Theater, New York on April 15, 1923. Four years later, the first talking feature film, *The Jazz Singer*, starring Al Jolson, debuts in New York on October 6, 1927.

The Bauhaus Movement, a school of art, design, and architecture was founded in Germany in 1919 and remained popular until the Nazis closed it down in the early 1930s. Werkbund, another artistic movement originating in Germany in 1907 by architect Hermann Muthesius, gained attention in the twenties as it attempted to harness the artist to machine production with the goal being to achieve quality through durable work and genuine materials.

technology and science

In November 1922, Lord Carnarvon and Howard Carter discover Tutankhamen's tomb at Luxor, Egypt.

Richard Byrd made headlines when he flew over the North Pole and the German airship *Graf Zeppelin* made a world flight.

International Style was a term given to a modern style of architecture that evolved in Western Europe in the 1920s, and became popular in the U.S. Its basic concepts are generally cubic shapes, often asymmetrical, and a great deal of window space; principles employed in buildings ranging from houses to skyscrapers.

The lingering effects of the war could be felt in the early 1920s as evidenced by the prevalence of subdued colors—partly due to the high cost of dyes and colorful clothing during the late-1910s and partly a reaction against all the bright colors that were so popular in the mid-1910s.

Color 1920s
Cues:

In the 1920s, women enjoyed more freedom than ever before and the timing couldn't be more perfect for French fashion designer Coco Chanel to debut on the fashion scene. Her designs influenced fashion, notable for her unique blend of minimal, modern thinking. Colors in the Chanel palette, which spread throughout the world in all facets of design, defines the minimalist palette and includes beige (PANTONE 488), taupe (PANTONE 4645), gray (PANTONE WARM GRAY), and black.

An entire range of pale colors was also dominant including celery (PANTONE 614), pale pink (PANTONE 691), lavender (PANTONE 664), powder blue (PANTONE 650), and light green (PANTONE 622).

Simultaneously, a lot of glitter came into play and the Art Deco movement, which had a huge influence on color, ushered in a lot of bronze (PANTONE 8960), chrome, steel (PANTONE 8002), and glass.

Despite the popularity of minimalist colors and metallic shades, bright color didn't totally disappear in the 1920s. Color was used, but used sparingly and typically softer shades prevailed. Bright color took on the Japanese-born tradition of being used occasionally as a spot or accent color.

1920s

Type
Tracker:

Influences

When Morris Fuller Benton took over as the director of typeface development for the American Type Founders, a conglomerate of about twenty-three type foundries established in the late 1800s, he built a library of typefaces based on his vision. The typefaces developed during his tenure carry his unique thumbprint and are noted for the humanistic feelings they evoke and their craftsman-like appearance, such as Parsons and Cheltanham.

Characteristics

Fonts of this period possess an eclectic blend of various characteristics. Many fonts originating during the twenties were designed to appear purposefully rugged such as Parsons and Packard. Simultaneously, typefaces developed during this time were influenced by the turn-of-the-century Victorians and, at the opposite end of the spectrum, the modern turns of the Art Deco movement.

Fonts of the 1920s

Perhaps the quintessential typeface of the 1920s is Broadway, seen by many as among the much-overused typefaces that illustrate the Roaring 20s. Ozwald, and today's version, ITC Ozwald, is another font evocative of the era, while Coronet typifies a 1920s script typeface.

Sans serif designs developed in the late 1920s were based on geometric forms. Sans serif fonts from the late 1920s that are still used today include German designs, Futura and Kabel, and their United States counterpart, Erbar. Franklin Gothic and News Gothic are sans serif designs that were also popular in the twenties, but they don't necessarily evoke an atmosphere of the era in graphic design pieces created today the same way that some of the others, such as Kabel. Gill Sans is also a 1920s typeface, but it did not really become popular until the 1930s and 1940s.

Typefaces owned and provided by Agfa Monotype.

Fonts you probably own that evoke the era:

EAGLE BOLD
ABCDEFGHIJKLMNOPQRSTUVWXYZI234567890

Cheltenham Bold
abcdefghijklmnopqrstuvwxyz1234567890
ABCDEFGHIJKLMNOPQRSTUVWXYZ

Cheltenham
abcdefghijklmnopqrstuvwxyz1234567890
ABCDEFGHIJKLMNOPQRSTUVWXYZ

Kabel Black
abcdefghijklmnopqrstuvwxyz1234567890
ABCDEFGHIJKLMNOPQRSTUVWXYZ

Kabel Book
abcdefghijklmnopqrstuvwxyz1234567890
ABCDEFGHIJKLMNOPQRSTUVWXYZ

Kabel Heavy
abcdefghijklmnopqrstuvwxyz1234567890
ABCDEFGHIJKLMNOPQRSTUVWXYZ

Kabel Light
abcdefghijklmnopqrstuvwxyz1234567890
ABCDEFGHIJKLMNOPQRSTUVWXYZ

Monotype Broadway
abcdefghijklmnopqrstuvwxyz1234567890
ABCDEFGHIJKLMNOPQRSTUVWXYZ

MONOTYPE BROADWAY
ABCDEFGHIJKLMNOPQRSTUVWXYZ1234567890

Ozwald
abcdefghijklmnopqrstuvwxyz1234567890
ABCDEFGHIJKLMNOPQRSTUVWXYZ

CONTEMPORARY
design
looks back

A sepia portrait of ad agency founder Leo Burnett, created expressly for this promotion, being carried through a busy Hong Kong marketplace in the early part of the twentieth century communicates with style that this firm is moving. Interestingly, the photo of this busy vintage street was taken around 1992. With a little retouching here and there, The Design Group turned the modern-day street into one from the twenties. The imagery is uniquely different, yet concise—communicating at-a-glance in the space of a postcard.

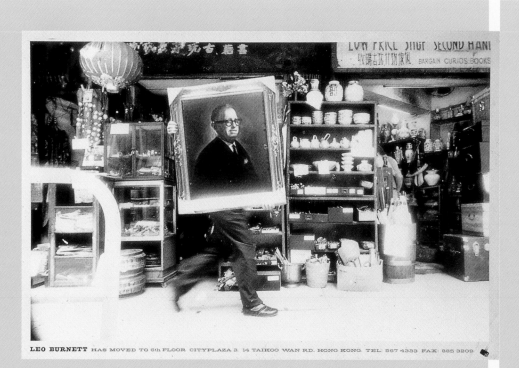

PROJECT: Leo Burnett Moving Postcard
CLIENT: Leo Burnett Hong Kong
DESIGN FIRM: The Design Group
ART DIRECTOR: Stefan Sagmeister
DESIGNERS: Stefan Sagmeister, Peter Rae, Mike Chan
PHOTOGRAPHER: Arthur Schulten

PROJECT: Pro-Pain "The Truth Hurts" Posters
CLIENT: Energy Records
DESIGN FIRM: Sagmeister Inc.
ART DIRECTOR: Stefan Sagmeister
PHOTOGRAPHER: Municipal Archives, New York City
PRINTER: Disc Graphics

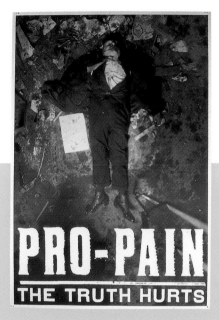

While the 1920s was known for its opulence and jazz, it had its dark side, too: the beginnings of mob-style crime brought about by gangsters who became as notorious for their personalities as for their bloody dealings. Their transgressions were regularly chronicled by photographers and here, Sagmeister Inc. used actual historical photographs from the Municipal Archives in New York to create these two posters for Pro-Pain, a metal band, with the headline: The Truth Hurts.

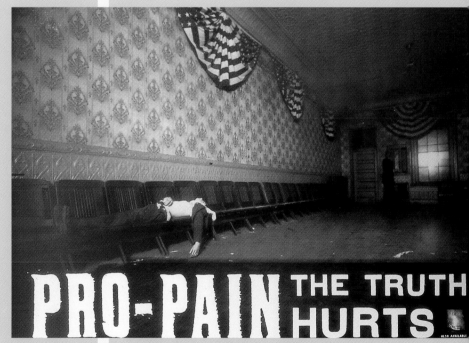

PROJECT: Hotel Astor Brochure

CLIENT: Hotel Astor

DESIGN FIRM: Turkel Schwartz & Partners

ART DIRECTOR: Rebecca Makovkka

COPYWRITER: Tom Schmidt

To reflect the Art Deco style of Miami Beach, Florida's Hotel Astor, designers created an Art Deco brochure that begins with the outside envelope that is notable for the distinguished logo in the upper left corner. The typography and pale celery on ivory color palette suits not just the Art Deco influence, but southern Florida as well. Inside, the brochure is wrapped in a subtle striped-vellum bellyband that is sealed with another variation on the logo—this time foil stamped in silver to give the appearance of chrome. "South Beach is in the heart of the Art Deco design (in Miami Beach) and the Hotel Astor is right in the middle of it," explained Marlisa Shapiro of Turkel Schwartz & Partners. "We chose typography reminiscent of that era (and) motifs we found in the property," she added, citing the patina on the hotel's walls, terrazzo floors, and port-holed exterior.

The clean smell of sunshine and FRESH salt air—this is aromatherapy, South Beach style.

For the LUCKY few who stay at the Hotel Astor, the MAGIC scent of the tropics extends beyond the BEACH.

Fragrant gardenias SWEETEN the air by day, while night wears a perfume of JASMINE.

Luxurious MARBLE baths breathe the wholesome aroma of NATURAL cleansing potions.

A passing whiff of the atrium restaurant TEMPTS even the most seasoned palate. But this is only the beginning.

Your stay at Hotel Astor will be a sumptuous FEAST for all of your SENSES.

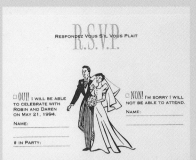

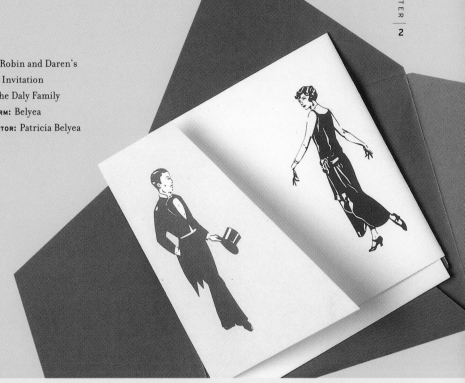

PROJECT: Robin and Daren's
Wedding Invitation

CLIENT: The Daly Family

DESIGN FIRM: Belyea

ART DIRECTOR: Patricia Belyea

"The flapper style and Erbe drawings of the
twenties reflected the personalities of the couple
getting married," said Patricia Belyea of this
period-inspired wedding invitation designed in
a subdued color palette of ivory and varying
shades of plum to pale lavender. "The drawings
in this invitation best reflect the era represented
by this design. Clean line drawings of men and
women in their finery hearken back to the time
of Josephine Baker and the flapper."

Discovery Networks' annual event was conducted in a historic theater
built in the 1920s, so designer Janice Davidson followed through
with illustrations in keeping with the period's advertising woodcut
designs. The architectural influences, typestyle, and black photo
covers all reinforce the look and feel of the era.

PROJECT: Upfront 2000 Invitation

CLIENT: Discovery Networks

DESIGN FIRM: Turkel Schwartz & Partners

ART DIRECTOR: Janice Davidson

What period has most influenced
your personal style of design?

"The period of graphic design in (the) early 1900s. Everything—Jugendsteil to Bauhaus to Dadism to Konstrucivism."
— *Janice Davidson, Turkel Schwartz & Partners*

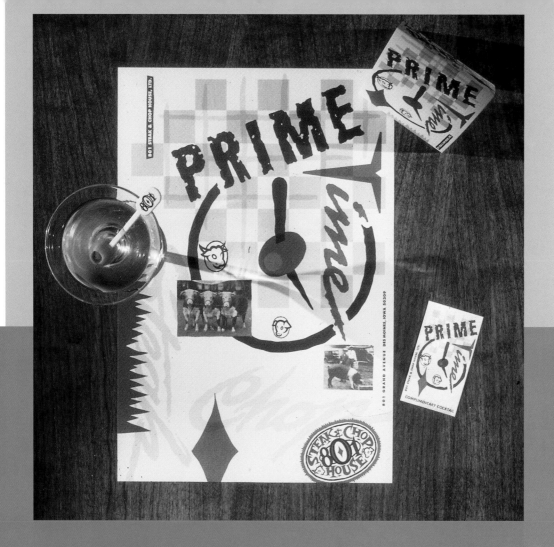

PROJECT: 801 Steak & Chop House
Interior & Collateral
CLIENT: 801 Steak & Chop House
DESIGN FIRM: Sayles Graphic Design
ART DIRECTOR/DESIGNER: John Sayles

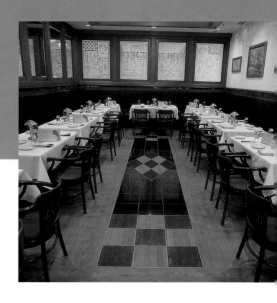

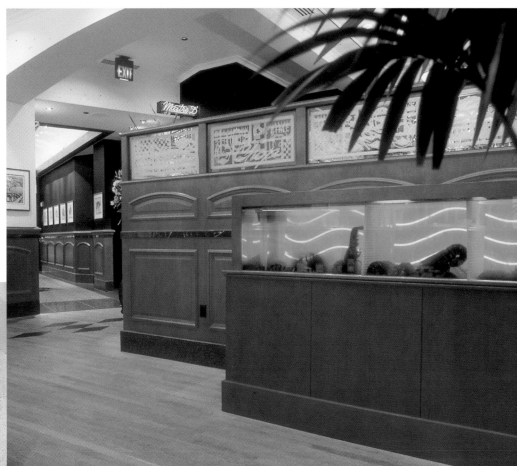

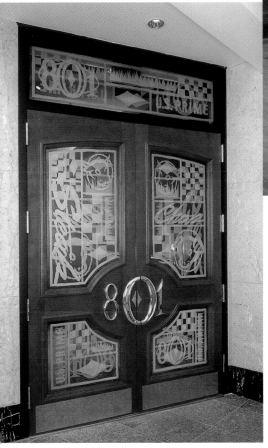

The 1920s were known for their opulent steak houses, so John Sayles used this era as the basis for his interior and collateral design for the 801 Steak & Chop House. The design features a preponderance of dark, rich woodwork, frosted, sandblasted glass, inlaid floor, and masculine furnishings—characteristics of the steakhouses of the early century. The same attention to detail and design is carried through to the collateral material including menus, toothpick wrappers, and matchboxes.

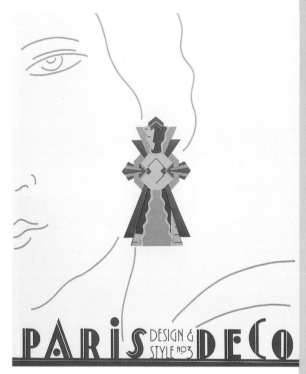

This cover for *Design & Style* integrates art deco-inspired typography, colors, and abstract stylized imagery against a line drawing of a woman to convey the sense of elegance that typifies the combination of the Art Deco aesthetic with Parisian influence—the result being, as noted on the magazine's cover—Paris Deco.

PROJECT: *Design & Style* Paris Deco Publication Cover
DESIGN FIRM: The Pushpin Group Inc.
DESIGNER/ILLUSTRATOR: Seymour Chwast
EDITOR: Steven Heller

"When you think of boxing, Jack Dempsey comes to mind (and) the 1920s was his decade, so I chose the poster designs of that time period" said Matt Graif of his firm's party invitation created as a direct mail promotion. Striving for authenticity, Graif employed a minimalist approach, using a grid layout that mimics the posters of the era. The color palette is also in keeping with the time period as it is printed in two colors, black and brown on a subdued yellow paper stock.

PROJECT: Tyson vs. Holyfield Fight Poster/Party Invitation
CLIENT: Graif Design, Inc.
DESIGN FIRM: Graif Design
ART DIRECTOR: Matt Graif
DESIGNERS: Matt Graif, Matt Rose
COPYWRITER: Matt Rose
PRINTER: Lorenz Printing

PROJECT: U.S. Cigar Identity and
Capabilities Brochure
CLIENT: U.S. Cigar
DESIGN FIRM: Hornall Anderson
Design Works, Inc.
ART DIRECTORS: Jack Anderson,
Larry Anderson
DESIGNERS: Larry Anderson,
Mary Hermes, Mike Calkins,
Brugman
ILLUSTRATORS: John Fretz, Jack Unruh,
Bill Halinann
COPYWRITER: John Frazier
PRINTER: Grossberg Tyler

The creative team at Hornall Anderson Design Works, Inc. took U.S. Cigar back to the 1920s, when the firm redesigned its logo and subsequently, created the cigar manufacturer's letterhead system and capabilities brochure. Inspiration for the logo came from the shape of actual cigar bands as well as the decorative ashtrays that were commonplace during the early century. Designers modeled the stationery after old ledgers from the twenties, and carried that look through to the capabilities brochure, which also borrows from the style of newspaper copy written during that era.

The Union Square Grill has an Art Deco interior so it made sense to create an identity in keeping with the restaurant's ambience. "The typography best reflects the 1920s Art Deco period and gives the restaurant the feel of being a Parisian restaurant," said Christina Arbini, spokesperson for the design team. Surprisingly, as shown here, the Art Deco look and vintage 1920s representation is easily conveyed—even in neon.

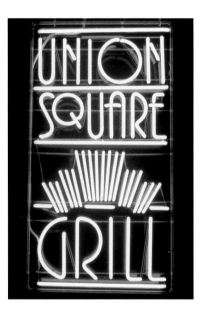

PROJECT: Union Square Grill Logo and Neon Signage
CLIENT: Union Square Grill
DESIGN FIRM: Hornall Anderson Design Works, Inc.
ART DIRECTOR: Jack Anderson
DESIGNERS: Jack Anderson, Mary Hermes, David Bates
ILLUSTRATOR: David Bates

PROJECT: Farmland Sweet Orange Marmalade Packaging
CLIENT: Coles Myer Ltd.
DESIGN FIRM: CPd-Chris Perks Design
ART DIRECTOR/DESIGNER: Chris Perks
ILLUSTRATOR: Anita Xhaffer

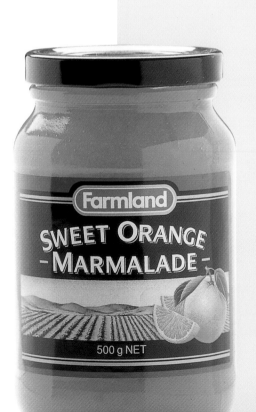

During the 1920s and 1930s, fruit crates carried practical and straightforward, yet very colorful and artistic artwork designating the product contained inside. Today, fruit crate label artwork is highly collectible and in this instance, provided the inspiration for the jar label for Farmland Sweet Orange Marmalade. Australian designer Chris Perks based the design on wooden crate labels carrying California oranges, depicting a picturesque orchard with a close-up of the fruit, which appears luscious and wholesome. The design possesses all the image characteristics of traditional fruit crate labels and the simple, unadorned typestyle is also true to form.

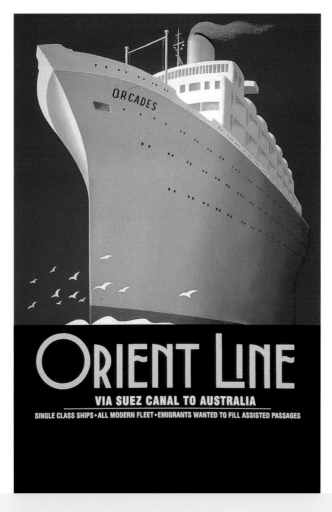

PROJECT: Orient Line Poster
CLIENT: Immigration Museum,
Melbourne-Victoria, Australia
DESIGN FIRM: Beattie Vass Design Pty Ltd.
ART DIRECTOR: Tom Beattie, Giota Vass
DESIGNER: Tom Beattie
ILLUSTRATOR: Bill Wood (Bill Wood Illustration)

Illustrator Bill Wood's rendition of the Orient Line accurately reflects the travel posters of the 1920s. The large steam-ships were the mode of travel during the period and this poster is authentic in that it has clean lines, a simple, yet strong typeface, and sets its larger-than-life imagery against a sumptuous color palette of gold and blue.

The Soviet Influence

The headline type treatments shown inside the figure on this brochure from Spain are examples of Soviet graphic design prevalent in the 1920s, which has a distinctive look all its own. "Soviet graphic design has a strong link with cultural aspects of communications," explained art director Emilio Gill, as to why he chose this imagery for a brochure reviewing the cultural magazines of Spain.

PROJECT: Revistas Culturales de España (Cultural Magazines from Spain)
CLIENT: Arce Asociación de Revistas Culturales de España
DESIGN FIRM: Tau Diseño
ART DIRECTOR/DESIGNER: Emilio Gil

THE HISTORY of flight

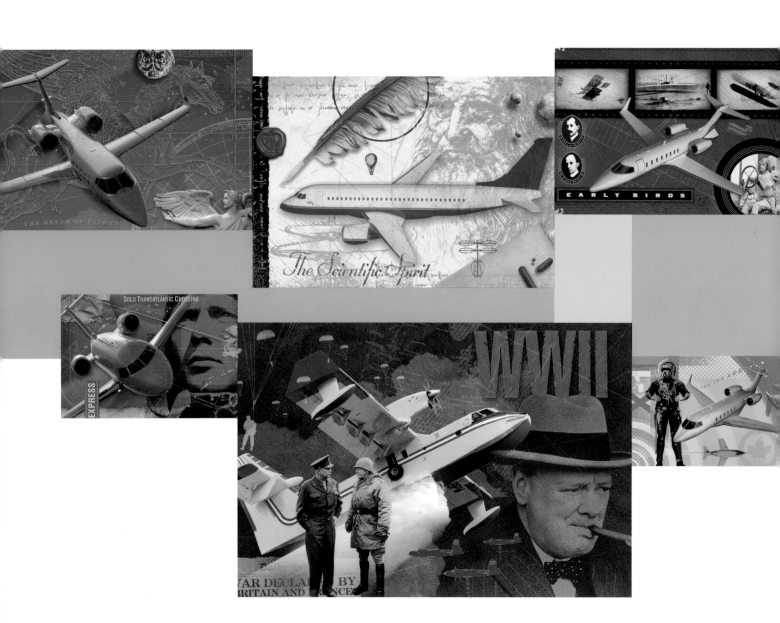

The Greteman Group put a lot of time and effort into this millennium calendar for Bombardier Aerospace, which graphically tracks the history and imagery of flight through the last century. Designers combined historical photographic images, some from the Corbis archives, with illustration for authenticity. The color palettes are true to each decade and reinforce the time travel nostalgia provided by the artwork that brings back memories with sepia photographs of the earliest days of flight at Kitty Hawk, North Carolina, the daredevil days of the barnstormers and the ominous look of planes during World War II to modern-day's passion for space exploration.

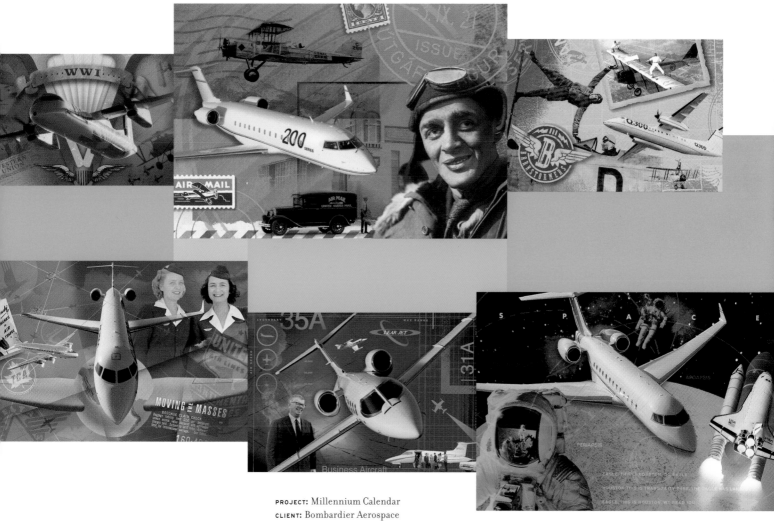

PROJECT: Millennium Calendar
CLIENT: Bombardier Aerospace
DESIGN FIRM: Greteman Group
CREATIVE DIRECTOR: Sonia Greteman
ART DIRECTORS: Sonia Greteman,
James Strange, Craig Tomson
DESIGNERS: Craig Tomson, James Strange
ILLUSTRATORS: Craig Tomson,
James Strange, Sonia Greteman
COPYWRITERS: Deanna Harms, Raleigh Drennon

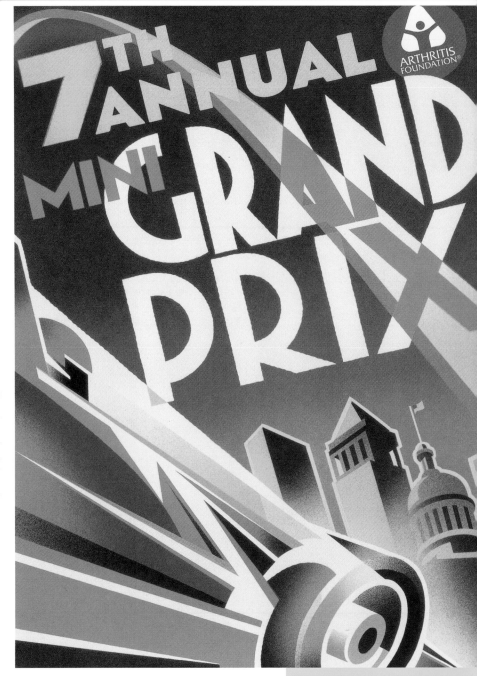

PROJECT: Arthritis Foundation's 7th Annual
"Mini Grand Prix" Poster

CLIENT: Arthritis Foundation

DESIGN FIRM: Louis London

ART DIRECTOR: Brent Wilson

DESIGNER/ILLUSTRATOR: Paul Rogers

the 1930s

The 1930s was a period of extremes—a decade sandwiched between two global crises: The Great Depression and World War II. The decade started out bleak; economic strife was far-ranging and jobs were scarce.

Drought conditions across the Midwest and Southwestern regions of the United States compounded problems for farmers and the area became known as the "Dust Bowl." The black-and-white imagery we hold of bread lines and migrant farmers and their families, packing what belongings they could fit on their truck and leaving their barren homes for the unknown, color our memories of this period.

These dreary pictures are often in startling contrast to that of the 1930s boom in entertainment, primarily the popularity of the radio and motion pictures—both inexpensive family entertainment and the purest form of escapism from daily strife. While most people struggled from day to day, not knowing where the next paycheck was coming from, they enjoyed, if only for a brief while, seeing how the other side lived—in glamorous romantic pictures, gangster films, and screwball comedies.

head lines OF THE 1930s

In 1931, Al (Scarface) Capone, an infamous gangster, was finally jailed for—of all things—income tax evasion.

In the hopes of pulling the U.S. out of the Great Depression, President Roosevelt used the expression "New Deal" for the first time in 1932.

On March 23, 1933, Adolf Hitler became dictator of Germany.

Britain introduced driving tests for the very first time on March 26, 1934.

On May 28, 1934, the Dionne quintuplets were born. Subsequently, the five little girls became the subject of a variety of product advertising campaigns, appearing on calendars and numerous premium items.

King Edward VIII became a romantic icon to millions around the world when he announced that he intended to marry Mrs. Wallis Simpson, a divorcee, in late 1936. He abdicated the throne and George VI succeeded him as King of England.

World War II began on September 1, 1939.

entertainment

The heydays of Vaudeville started to wane as people flocked to movie theaters instead of going to live stage performances. Dixieland Jazz became a popular style of music with its origins in the Southern U.S. Jitterbugging, a lively and athletic form of dancing, became popular in the late 1930s and prompted the beginnings of boogie woogie, a jazzy style of piano playing. Jive, a later, more sober and respectable form of jitterbugging, was also popular. The Rumba was the fashionable dance in 1935. The prevalence of the big bands commercialized jazz for the masses and launched swing music. Swing was launched in the mid-1930s and continued to be popular through 1946—a period known as the Swing Era.

In May 1936, The MacMillan Publishing Company, New York, published Margaret Mitchell's Civil War romantic epic, *Gone With the Wind*, which proceeded to break all sales records in the U.S. and became a best seller abroad as well. Within a month of its publication, Hollywood producer David O. Selznick paid a record sum—$50,000—for the motion picture rights to the book. His film version starring Clark Gable and Vivien Leigh premiered in Atlanta, Georgia, December 13, 1939. The story was among Adolf Hitler's favorites until he learned that it was a source of inspiration among the resistance movement, prompting him to ban the novel and the film in all German-occupied countries.

Some of the biggest stars of the decade included Clark Gable, Spencer Tracy, Jean Harlow, Greta Garbo, Joan Crawford, Humphrey Bogart, James Cagney, the Marx Brothers, Bette Davis, Claudette Colbert, Myrna Loy, William Powell, and Carole Lombard.

art
and architecture

Architect Frank Lloyd Wright enjoyed some of his most creative years during the mid-1930s. Some of his most famous works were created then, including: Fallingwater, a luxurious weekend home in Pennsylvania, the S.C. Johnson and Son Administration Building in Wisconsin, and the first of a series of "do-it-yourself" houses Wright referred to as Usonian—the Jacobs house, also in Wisconsin. He was the pioneer of the Prairie school, characteristic of houses with low-pitched roofs and extended lines that blended into the landscape.

technology and science

The ballpoint pen was invented by Lázlo Biró in 1938. On May 20, 1939, Pan American airlines started regular flights between the U.S. and Europe. Nylon stockings made a big hit with women—and men, too—when they were introduced in 1939.

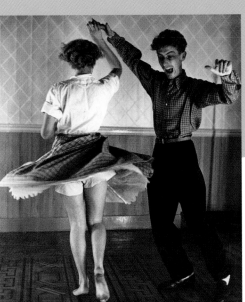

When we think of the 1930s, the colors of the Great Depression come to mind—somber gray (PANTONE 432) black, and brown (PANTONE 4625). But this palette was really only prominent in the early part of the decade—1930 to 1931—when bleak colors reflected the impact of the economic reality. Between 1932 and 1933, the pendulum swung back and the opposite of dark colors, which was a total absence of color—white—became popular because of its association with sunshine.

Color 1930s
Cues:

In fact, it was during this time that people began pursuing suntans in order to get that "healthy" look. White was the color that best showed off a good tan. The trend carried into interior decorating, too. Suddenly, against popular convention, trendsetters decorated interiors with all white, white-on-white themes.

White cars—prominent among the wealthy—debuted in the decade in startling contrast to the black automobiles, which were the norm.

White also evolved into the popularity of off-whites, ivories, and soft pastels (PANTONE 9042, PANTONE 9061, PANTONE 9060, PANTONE 9021, PANTONE 9023, PANTONE 9381, PANTONE 9041), never more evident than in the movies of the era that boasted platinum blond bombshell Jean Harlow undulating in satin sinuous gowns of these colors.

Gilding, seen on furniture legs and figurines, was also started in the '30s.

Ultimately, however, one can only experience so much white before the need for color began creeping back into the palette. By the mid-30s, lots of colors were used, most notably in unusual and complex combinations. For instance, periwinkle blues (PANTONE 2725) were shown with taupe or brown (PANTONE 264) and Dijon yellows (PANTONE 110) were combined with charcoal gray (PANTONE 426). Many of the color palettes were borrowed from the great ocean liners of the era with their sumptuous décor, which was notable for its complex color palettes.

The era saw the first suggestion of a cocktail dress with the introduction of the chic little black dress. The 1930s is also known for the debut of shocking pink (PANTONE 211).

In all, it was an era of bountiful color use and experimentation. "In these compressed ten years, a lot happened with color. It is the decade between two very important events—the Depression and World War II," says Leatrice Eiseman, director, Pantone Color Institute. Had it not been for the war, the decade "would have sparked a lot more color invention."

Type Tracker:

1930s

Characteristics

Typefaces in the 1930s ranged from very conservative text designs to elaborate display fonts. Typefaces with art deco influences are also characteristic of the period. Art deco-inspired fonts are generally mannered designs with strong thick and thin contrasts to the strokes such as Radiant, Piranes Script. They have a small x height and tall ascenders. Examples of fonts with tall ascenders include Stymie Elongated and Radiant. Many fonts are notable for their heavy, dark designs such as Goudy Stout. Conversely, another '30s font, Huxley Vertical, is quite light by contrast, which proves that designers in the '30s worked in both extremes.

Influences

Art deco, both in art and architecture influenced type design in the 1930s. European design, which was a trend-setter for design in the early part of the century, was another influence. Many designers created hand-lettered art deco forms; those that became popular would be taken to type foundries and turned into cost-effective typefaces for printers and publishers.

Fonts of the 1930s

Times Roman was developed in 1932, as were other text fonts. Though not typical of the thirties, the decade saw the first wave of geometric sans serif fonts including Futura, Gill, Granby, and Metro. Out of the Bauhaus movement were fonts more indicative of the period such as Egyptian slab serif fonts Memphis, Stymie, and Karnac—all of which were available in the 1800s as display fonts, but were not introduced as font families until the '30s. Popular script typefaces included Kaufman Script and Keynote Script.

Typefaces owned and provided by Agfa Monotype.

Fonts you probably own that evoke the era:

T

GRECO SOLID
ABCDEFGHIJKLMNOPQRSTUVWXYZ1234567890

T

Hollywood Deco
abcdefghijklmnopqrstuvwxyz 1234567890
ABCDEFGHIJKLMNOPQRSTUVWXYZ

T

Dynamo
abcdefghijklmnopqrstuvwxyz1234567890
ABCDEFGHIJKLMNOPQRSTUVWXYZ

T

Bernhardt Bold
abcdefghijklmnopqrstuvwxyz1234567890
ABCDEFGHIJKLMNOPQRSTUVWXYZ

T

Bernhardt Medium
abcdefghijklmnopqrstuvwxyz1234567890
ABCDEFGHIJKLMNOPQRSTUVWXYZ

T

Bernhardt Light
abcdefghijklmnopqrstuvwxyz1234567890
ABCDEFGHIJKLMNOPQRSTUVWXYZ

CONTEMPORARY
design
looks back

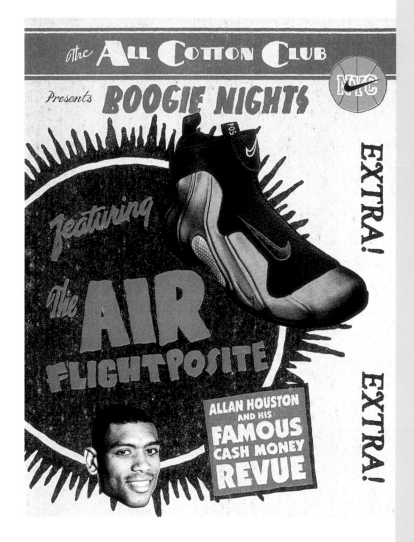

PROJECT: "All Cotton Club-New York City Attack" Outdoor Advertising

CLIENT: Nike

DESIGN FIRM: Plazm Media, Inc.

ART DIRECTOR: Danielle Flagg

DESIGNERS: Joshua Berger, Pete McCracken, Lotus Child, Jon Steinhorst

COPYWRITER: Jimmy Smith

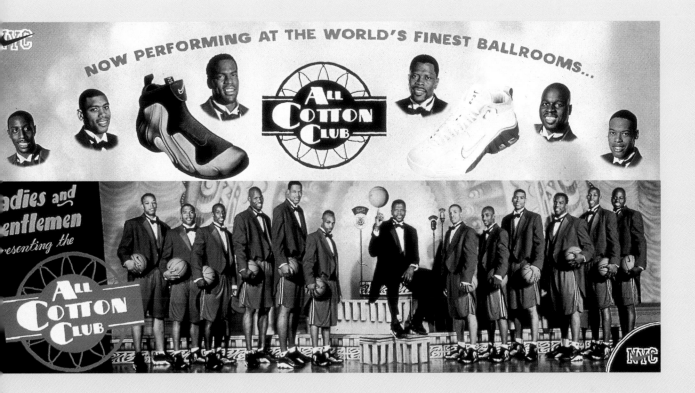

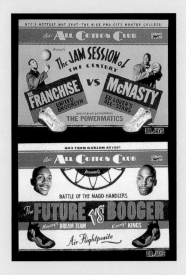

To promote the benefits of Nike's two new performance basketball shoes, designers created outdoor advertising materials used in bus shelters and subway venues with a retro-style art deco layout that resembles New York's famed Harlem Cotton Club nightclub graphics of the '30s and '40s. "These motifs stand in contrast to modern ad motifs," said Joshua Berger, one of several designers on the project. "By integrating iconic professional stars, NYC street legends of today, and Nike brand messaging, the campaign suggested marketing goals in a friendly, consistent, and accessible manner."

With an eye toward historical accuracy, designers did not use any standard fonts, but hand-lettered all the type. The photograph of the tuxedo-clad basketball players is authentic from its sepia-tones and costuming of the players to the backdrop. The illustrations are equally true to the period. According to Berger, designers hand-rendered all the art and then put the art through a special "aging process" so that it would appear authentic.

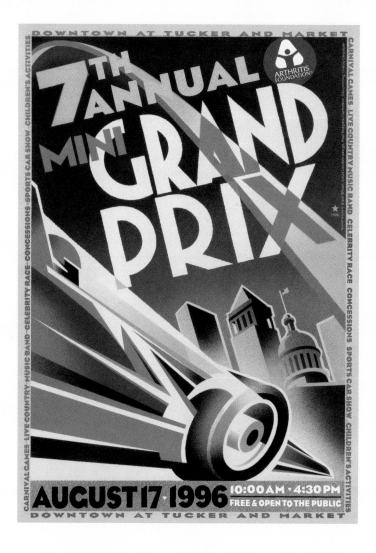

Collectible Monaco race posters and train posters of the 1930s provided the
color, typography, and texture cues for this poster created by Paul Rogers for
the Arthritis Foundation's 7th Annual Mini Grand Prix event. Bold, sans
serif type, set on an angle, and a simple three-color palette combine with the
illustration to convey the mood of a mid-century poster.

PROJECT: Arthritis Foundation's 7th
Annual "Mini Grand Prix" Poster
CLIENT: Arthritis Foundation
DESIGN FIRM: Louis London
ART DIRECTOR: Brent Wilson
DESIGNER/ILLUSTRATOR: Paul Rogers

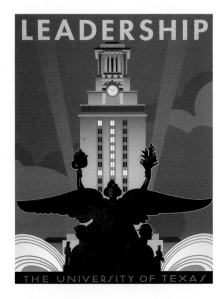

"GSD & M wanted to draw on the inspirational designs of the WPA and the world's fair posters of the '30s and '40s," said Paul Rogers, designer and illustrator of this series of posters for the University of Texas. The period was chosen because the objective was to capture "a modern feeling of optimism and energy (that) was reflected in posters of that period," Rogers explained. Using a minimalist approach to copy, the bold one-word headlines "Leadership" and "Responsibility" immediately convey what the university is all about.

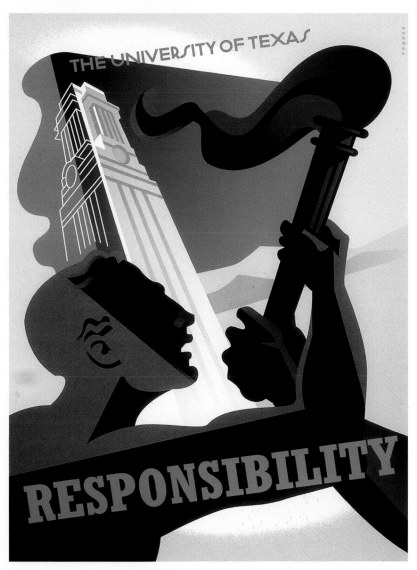

PROJECT: University of Texas Poster
CLIENT: University of Texas
DESIGN FIRM: GSD&M
ART DIRECTOR: Craig Denham
DESIGNER/ILLUSTRATOR: Paul Rogers

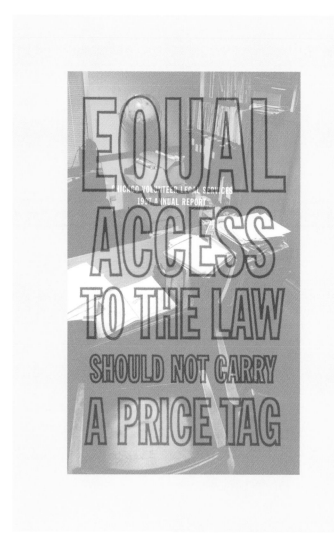

The 1930s "was a period in American history during which equal access under the law was emphasized. The economic stress that the nation confronted during the Great Depression caused people of all socio-economic backgrounds to come together," said designer Tim Bruce, explaining why the 1930s was chosen as the theme for the Chicago Volunteer Legal Services' annual report. "During times of hardship people are more inclined to reach out to help others. They are less focused on economic gain and more on the quality of life of their community."

To recreate the atmosphere of the Depression era, Bruce hand-lettered type onto translucent stock for the fly-sheet cover and section introduction pages to replicate the look of glass office doors of the '30s. The sturdy, no-frills letterforms combine with the present-day sepia-toned photography to recreate the atmosphere of the Depression era, and in this case, one also gets the feeling that Chicago Volunteer Legal Services' door is always open.

CHICAGO VOLUNTEER
LEGAL SERVICES

CONSUMER
LAW

CVLS
PROBATE
&
ESTATES

PROJECT: Chicago Volunteer
Legal Service Annual Report
CLIENT: Chicago Volunteer Legal Service
DESIGN FIRM: Lowercase, Inc.
ART DIRECTOR/DESIGNER/ILLUSTRATOR:
Tim Bruce
PHOTOGRAPHER: Tony Armour
COPYWRITER: Margaret Benson
PRINTER: H. MacDonald Printing

〔 19 〕

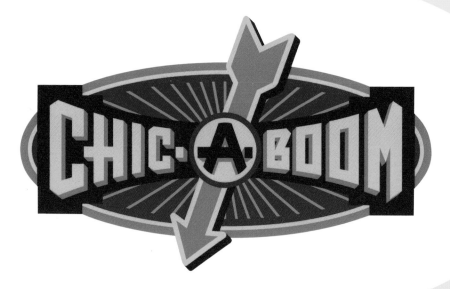

Michael Doret didn't consciously choose the 1930s as the theme for this store signage, but as the design evolved so did the aesthetics of 1930s design. The bold letterforms and the unusual color combinations are characteristic of the era. "The design reflects our (American) heritage of roadside signage whose heyday was the '20s through the '40s," said Doret.

PROJECT: Chic-A-Boom Signage
CLIENT: Chic-A-Boom
DESIGN FIRM: Michael Doret
Graphic Design
ART DIRECTOR/DESIGNER/ILLUSTRATOR:
Michael Doret

OPPOSITE PAGE
PROJECT: General Amusements Logo
CLIENT: Red Sky Interactive
DESIGN FIRM: Michael Doret
Graphic Design
ART DIRECTOR: Joel Hladecek
DESIGNER/ILLUSTRATOR:
Michael Doret

color in the movies

One might say that nearly 99 percent of all motion pictures made in the 1930s were black-and-white, but the few that were made in color had an indelible impact on the film industry and all succeeding generations to ever sit in a darkened movie theater. Walt Disney's *Snow White and the Seven Dwarfs* was released in 1937 and is notable as the first feature-length animated cartoon, but also because it was in color—in contrast to Disney's 1928 *Steamboat Willie*, which introduced Mickey Mouse, and the popular Betty Boop cartoons. But the real boom in color motion pictures didn't come until the last moments of the decade: 1939. In that single year, two of the most important films in cinematic history were produced: MGM's *The Wizard of Oz*, which began as a sepia-colored film before transitioning into Technicolor and then back again to sepia tones, and David O. Selznick's masterpiece, *Gone With the Wind*. With its nearly four hour running time, one critic noted that viewing Technicolor for that length of time was hard on the eyes.

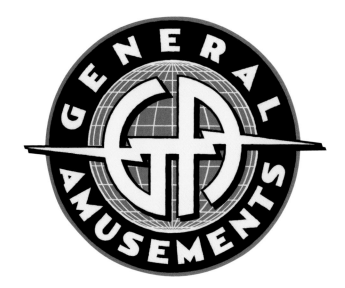

This logo for General Amusements makes excellent use of a limited color palette, which, combined with the typestyle and its irregular edges, depict the characteristics inherent in 1930s American design. Designer and illustrator Michael Doret says that he chose the period for the logo because of its extremely low-tech aesthetic.

What period has most influenced your personal style of design?

"I have always been inspired by such diverse sources as matchbook covers, theater marquees, enamel signage, packaging, and various other memorabilia and ephemera from the '20s through the '60s." —*Michael Doret, Michael Doret Graphic Design*

PROJECT: Expand Your Horizon Promotion
CLIENT: Fort Dearborn Insurance
DESIGN FIRM: Sayles Graphic Design
ART DIRECTOR/DESIGNER/ILLUSTRATOR: John Sayles
COPYWRITER: Wendy Lyons

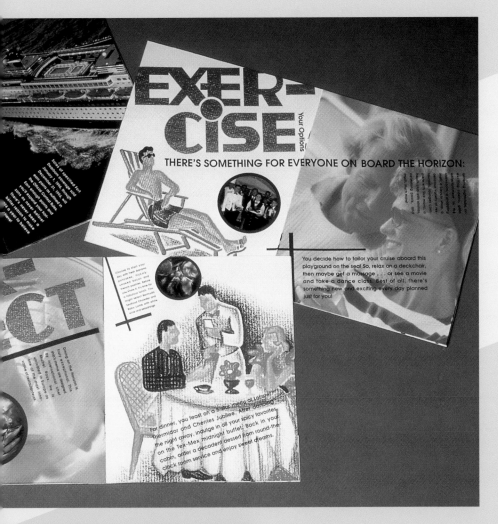

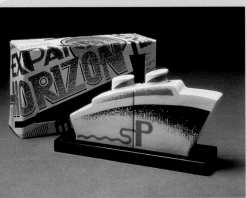

When the time came to promote a special cruise for the company's top performers, Fort Dearborn Insurance turned the job over to Sayles Graphic Design, which promptly established a theme based on the 1930s—an era of elegant ocean liners and regular crossings of the Atlantic for business and pleasure with their own identifiable style of advertising posters. John Sayles began by creating a limited-edition poster of his own featuring an original charcoal illustration using ten colors and printed on a thick, cloth-like paper, which he signed and numbered. Next, he created promotional brochures that continue the theme with an attention to detail down to the thirties-era striped chaise lounge. Finally, as a special commemorative gift for the seventy-five lucky agents who earned the trip, Sayles produced a custom salt and paper shaker set in the shape of a cruise ship.

PROJECT: American Royal Poster

CLIENT: American Royal

DESIGN FIRM: Muller & Company

ART DIRECTOR/DESIGNER: Mark Botsford

COPYWRITER: Pat Piper

The blue and tan color palette, colors not usually combined until the experimental 1930s, and especially the sectional layout of this poster are characteristically 1930s in design. Muller & Company created the piece to spoof instructional posters of the period.

Outdoors equipment and clothing retailer Eddie Bauer, seller of Sac Jac, a jacket that folds into a pouch, needed a label to distinguish its product packaging. The product was originally launched in 1936 and was re-introduced by Eddie Bauer in the late-1990s as retro shtick, according to designer David Lemley. It was this interesting product history that Lemley called upon when creating the packaging label. The "typography is handmade (and is) based on samples of Hess Neo-Bold, a 1930s face," explained Lemley. As for the color palette, Lemley used hues that reminded him of those sported on camping gear of the thirties and forties.

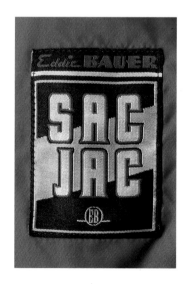

PROJECT: Sac Jac Label Design

CLIENT: Eddie Bauer

DESIGN FIRM: David Lemley Design

ART DIRECTOR: Teresa Gallagher

DESIGNER: David Lemley

The creative team at Plazm Media, Inc. relied upon revival-style deco layouts to recreate the look of classic Harlem nightclub graphics of the thirties and forties—the era when Duke Ellington enjoyed his heyday—when designing comprehensive CD packaging and promotion for Dr. John's newest CD, aptly titled *Duke Elegant*. Hand-lettered type and a thirties color palette help achieve authenticity, while designers also developed their own technique for "aging" the art to make it appear even more historically accurate.

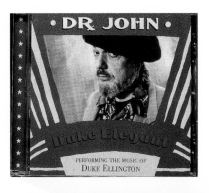

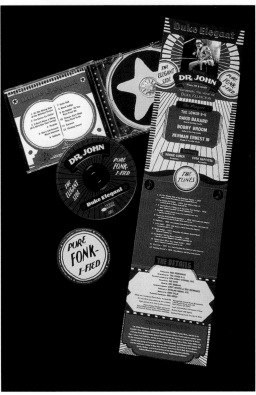

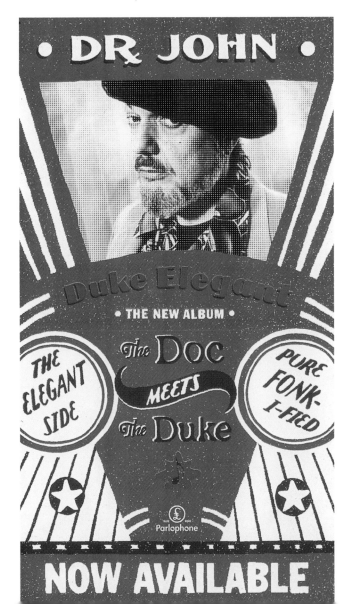

PROJECT: Dr. John *Duke Elegant* CD Packaging and Promotion

CLIENT: Blue Note Records

DESIGN FIRM: Plazm Media, Inc.

ART DIRECTORS: Joshua Berger, Pete McCracken

DESIGNERS: Jon Steinhorst

COPYWRITER: Dr. John, Stanley Moss

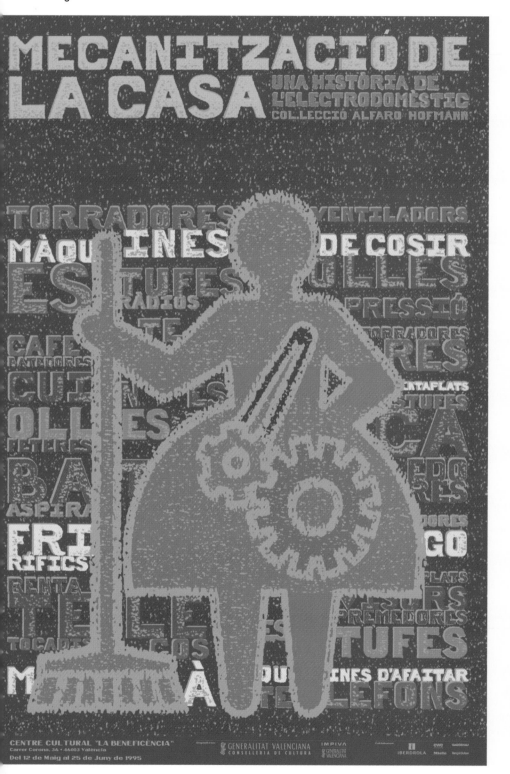

This poster, created for an exhibition in Spain of household appliances and their evolution throughout the twentieth century, got its inspiration from a similar poster created by designer Francis Bernard in 1930, according to Pepe Gimeno. "We chose it because many items from the exhibition...date back to this time and we also wanted the image of the exhibition to have a historic nature," explained Gimeno. "The choice of typesetting, which reminds one of the fonts made with wood, the false mismatching of colors, and the texture, remind one of the prints made by xylography."

PROJECT: Mecanització de la Casa (Mechanization of the Home) Poster

CLIENT: Generalitat Valenciana (Autonomous Community Authority), Department of Culture

DESIGN FIRM: Pepe Gimeno·Proyecto Gráfico

ART DIRECTOR: Pepe Gimeno

DESIGNER: Ana Iranzo

PRINTER: Pentagraf

PROJECT: 9th National Design
Competition Announcement
CLIENT: Valencia International Trade Fair
DESIGN FIRM: Pepe Gimeno-Proyecto Gráfico
ART DIRECTOR: Pepe Gimeno
DESIGNER: Juan Nava
PRINTER: Gráficas Vicent

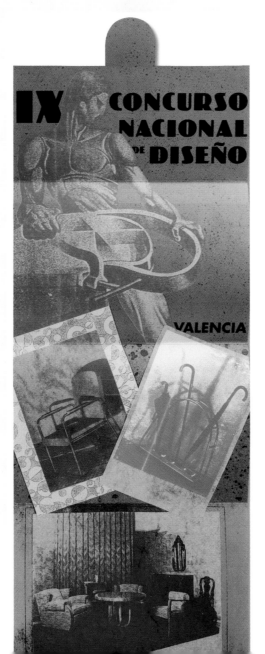

The thirties was "the age just before the
Spanish Civil War, when the exile of artists
and designers had not yet taken place with its
(resulting) immense cultural vacuum. The
most interesting expressions of modernity
up to the sixties were found at this time,"
said Pepe Gimeno from his design studio in
Spain as he explained the reasoning behind
the historical design characteristics of this
piece announcing an international design
competition sponsored by the Valencia
International Trade Fair. Its style and the
contents of the photographs—furniture with a
unique bent wood design—are indicative of
the period.

UNION STATION

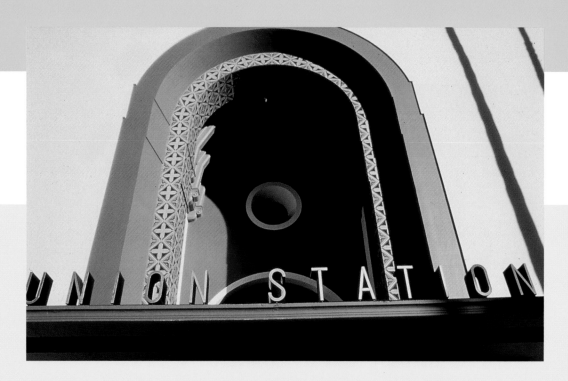

PROJECT: Union Station Identity, Environmental
Design, and Wayfinding System

CLIENT: Catellus Development

DESIGN FIRM: Selbert Perkins Design Collaborative

CREATIVE DIRECTOR: Clifford Selbert

DESIGNER: Brian Lane

PHOTOGRAPHER: Anton Grassl

TRAXX
BAR

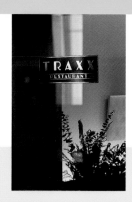

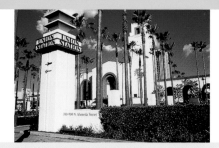

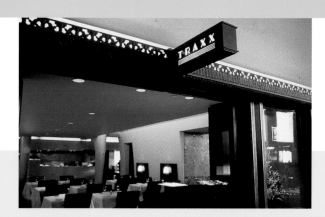

It was the heyday of railroad travel so it's no surprise that train stations were luxurious destinations in the 1930s. So, when it came time to restore Los Angeles' Union Station, a prominent landmark for its architectural and historical significance, Selbert Perkins Design Collaborative (SPD) researched original drawings and historical imagery to complete the task as accurately as possible. The result is a combination of architectural influences from Spanish Colonial Revival, American Art Deco, Streamlined 1930s Modern, and Mediterranean styles.

The signage itself, appears in a couple of variations—from the logo, which is actualized on the outdoor signage, to a more streamlined version accentuating the building's main entrance beneath a terra cotta archway. Designers paid meticulous attention to every detail to ensure that the furniture designs, including benches, trash receptacles, light fixtures, and even the telephone signage, were historically accurate.

In addition to recapturing the look of the train station, SPD also created the identity for the station's retail components, including Traxx, a restaurant and bar. Designers treated Traxx to a stylized logo and refreshingly, upscale interior décor.

"By combining stylistic elements of color, typography, material, lighting, structure, and architectural details, SPD established a seamless identification and wayfinding system," said Clifford Selbert. "Remaining sensitive to the original vision of the station, these communication elements will, in turn, remain as timeless as Union Station itself."

Travel stickers, popular during the thirties, can be found today adorning old luggage and steam-ship trunks as colorful reminders of days when resorts, cities, and other attractions were portrayed with one iconographic symbol and distinguished typestyles. Here, designer Mike Quon created a series of travel stickers reminiscent of the period, using various label shapes, type treatments, colors, and illustrations—all diverse, yet all representative of the age when travel was a grand experience. The images were subsequently used to dress-up the cover of Time Inc.'s *Best Choices* magazine, featuring a story on cities ideal for retirement living —incidentally appealing to readers of retirement age with a fondness for the vintage inspired labels.

PROJECT: Travel Stickers
CLIENT: Time Inc.
DESIGN FIRM: Mike Quon/Designation Inc.
ART DIRECTORS: Mike Quon, Charles Wallace
ILLUSTRATOR/PHOTOGRAPHER: Mike Quon

THE
history
OF NBC

NBC got its first official logo, a micro-
phone surrounded by lightning bolts,
in 1943-four years after inaugurating
television service.

A xylophone and mallet logo was
introduced on New Year's Day, 1954.
The xylophone played the now famil-
iar three-tone NBC chimes (which
were first heard on NBC radio in
1927). The chimes were composed of
the musical notes G, E, and C, which
were chosen because they represent-
ed the initials of the network's co-
founder and subsequent owner, the
General Electric Company.

NBC unveiled what the company calls
the "Bird," to commemorate its color
broadcasts in 1956. The bird, an
eleven-feathered peacock that was
rendered in six colors, was flashed at
the beginning and end of color shows.
(The popular children's show, *Kukla,
Fran & Ollie* was NBC's first color
broadcast in 1953. The network offered
full color broadcasting in 1956, nine
years ahead of the other networks,
according to company literature.)

The National Broadcasting Company (NBC)

was an industry pioneer first in radio and subsequently, in television. Since its inception in 1926, the network has reinvented itself with innovations and advancing technology that have kept it at the forefront of the industry. According to the network, NBC was the first permanent broadcasting network in the U.S. and the first to offer coast-to-coast radio broadcasting. It was the first U.S. commercial television station, now known as WNBC, in 1941 and was the first to provide coast-to-coast network television service in 1951. NBC debuted the first color telecast in 1953 and was the first to broadcast in stereo in 1984. Today, it has the distinction of being the first network to broadcast both on-line and in digital high definition format.

While the network has continued to evolve to meet the market's ever-changing technology, similarly, its logo has also evolved over the years—from the early days of radio, illustrated by a lightning bolt, to the stylized version of the proud peacock we know today.

In 1959, NBC debuted "The Snake" logo, which appeared at the end of individual shows. Each letter was animated and grew out of the N to form a stacked typographic logo.

In 1975, the network updated its logo to a solid letter N, formed by two trapezoids, one colored red and the other blue. The logo modernized NBC's appearance, but its lifespan was short as a small television station in Nebraska was using the logo.

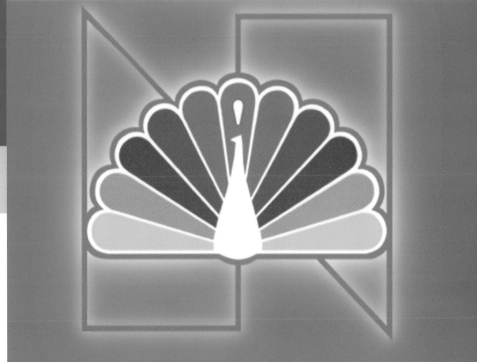

In 1980, solid letter N was lightened in color and moved to the background, while the foreground featured a new peacock. This peacock still had eleven feathers, but to keep with the modernist approach, the shapes of the feathers were simplified and the feathers' tips and the bird's feet were eliminated.

"The Bird" returned to its place as NBC's proud symbol without the letter N in 1986. It no longer had eleven feathers, but now only six feathers—each representing one of the network's six divisions. This version of the peacock remains one of the world's most recognized logos.

PROJECT: "What a Wonderful World!"
Holiday Greeting Card

CLIENT: Michael Doret

DESIGN FIRM: Michael Doret
Graphic Design

ART DIRECTOR/DESIGNER/ILLUSTRATOR:
Michael Doret

the 1940s

The first half of the 1940s was filled with war and the second half was spent recovering from its devastation. With men in the military, women went to work on the home front, taking jobs in factories that took them out of the home for the first time. Men weren't there to do the work; so women filled their shoes, giving them independence they never had before.

In times of war, entertainment—music and dances—provided a brief respite and the era generated a wealth of war songs—"I'll Be Seeing You," "I'll be With You in Apple Blossom Time," and "Lili Marlene," that remain popular today. Big bands entertained at home and visited the troops, along with other big name celebrities, who sought to bring the feeling of home to the boys at the front.

With peace at hand once more, men returned to find few if any jobs, but slowly rebuilt their lives. Women returned to the home and devoted themselves to being housewives and mothers, and thus, the first children known as the "baby boom generation" were born.

head
lines OF THE 1940s

December 7, 1941 the United States enters World War II.

The war continued in Europe until May 8, 1945 and in the Pacific until August 14, 1945.

Meanwhile, women's suffrage becomes law in France in 1945 and one year later, in 1946, Italy gave women the right to vote.

On November 20, 1947, Princess Elizabeth married Philip Mountbatten, Duke of Edinburgh.

Siam changed its name to Thailand on May 11, 1949.

entertainment

Bebop, an intellectual type of jazz that started in the 1940s comes into fashion, while the swing era continues to be popular. "Lili Marlene" is a popular song in Germany in 1940. The Andrews Sisters and Bob Hope are big names in entertainment as they visit the troops throughout the war. The "New Look" female fashion is in vogue.

technology and science

In 1942 magnetic recording tape was invented and the first electronic computer was built. In 1945, Chester Carlson invented xerography.

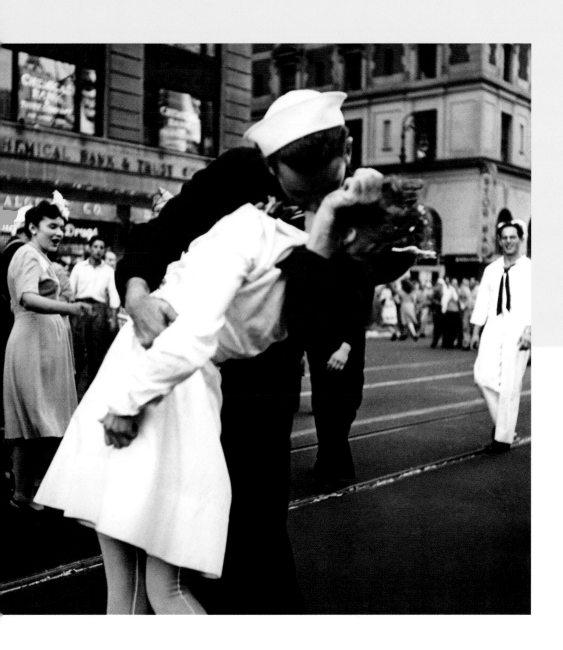

For the most part, colors in the 1940s took on a dusted quality, as dyestuffs were increasingly hard to get during the war years and the dyes that were available were largely composed of gray. Gray, itself, was prevalent in light (PANTONE 422) and dark shades (PANTONE 436), while colors like yellow (PANTONE 458), orange (PANTONE 472), mauve (PANTONE 500), navy (PANTONE 534), and green (PANTONE 5555) appeared chalky, muted, and unsaturated. However, the decade didn't start out this way.

Color Cues: 1940s

Going into the forties, colors were bright; cherry red lipsticks (PANTONE 1925) accented lively colors of hues of pink (PANTONE 196) and yellow (PANTONE 127). But, as the war escalated, colors began to lose their vitality since the bulk of dyes, which were manufactured in Germany, were not available. Ultimately, French fashion designers came to the rescue, making fashion statements out of the colors that were abundant—olive (PANTONE 455), khaki (PANTONE 4515), navy (PANTONE 539), and black.

Moreover, because dyestuffs were rationed and the availability of textiles was limited, the style and lines of clothing changed, too. Skirts became shorter and clothing became slimmer and more tailored—out of necessity—to minimize the fabric required.

As the war dragged on, the only place one would see color was in the hand knit caps, gloves, and sweaters that were made on the home front from leftover clothing. Drab military uniforms and civilian fashions were often accented with spots of "homemade" color. Of course, throughout the war, cosmetics were considered a morale booster, and shades of pink and red, the latter for lips and nails, continued to be popular throughout the decade.

Naturally, throughout the war, a country's colors signaled patriotism and the brighter, the better. In the U.S., shades of vibrant red (PANTONE RED 032), white, and blue (PANTONE 286) were prevalent.

By the latter part of the decade, color made a comeback in—of all things—"resort" clothing. The thinking was that summertime clothing was less expensive, so wild, vibrant colors were less of a fashion and investment risk. Popular tropical colors ranged from tangerine (PANTONE 123) and yellow (PANTONE 120) to vibrant teal (PANTONE 3265), fuchsia (PANTONE 2385), and purple (PANTONE 2582) to true blue (PANTONE 2727) and turquoise (PANTONE 306). The advent of these colors paved the way for the color palette of the 1950s.

Type Tracker:

1940s

Characteristics

Slab serif typefaces were popular in the forties and were a primary focus. Fonts such as Beton, Cairo, Stymie, and Karnac were popular as both text and display faces and also quite distinctive. Meanwhile, many of the fonts from the 1930s remained popular. There was a holdover of elegance in typefaces, but the forties now considered many of the faces with the 1930s Art Deco influence passé.

Influences

Because of the war, very few new fonts debuted in the 1940s. Type foundries were turned into ammunition factories, making bullets or small arms.

Fonts of the 1940s

Among the typefaces true to the era, but not necessarily illustrative of the period include: Fairfield, a text font, which is fairly non-descript, Bernhard Tango, and Cartoon Light, many of which are no longer available—at least in a digital format. Anyone looking to find and research these older fonts can do so by picking up a copy of *American Metal Typefaces of the Twentieth Century* by Mac McGrew and published by Oak Knoll Books, New Castle, Delaware, 1993.

Typefaces owned and provided by Agfa Monotype.

Fonts you probably own that evoke the era:

T
Monotype Lydian
abcdefghijklmnopqrstuvwxyz1234567890
ABCDEFGHIJKLMNOPQRSTUVWXYZ

T
Monotype Lydian Cursive
abcdefghijklmnopqrstuvwxyz1234567890
ABCDEFGHIJKLMNOPQRSTUVWXYZ

T
Bernhard Modern
abcdefghijklmnopqrstuvwxyz1234567890
ABCDEFGHIJKLMNOPQRSTUVWXYZ

T
Park Avenue
abcdefghijklmnopqrstuvwxyz1234567890
ABCDEFGHIJKLMNOPQRSTUVWXYZ

T
PL Radiant
abcdefghijklmnopqrstuvwxyz1234567890
ABCDEFGHIJKLMNOPQRSTUVWXYZ

CONTEMPORARY
design
looks back

Designer/illustrator Paul Rogers took his inspiration for this poster campaign from the propaganda posters disseminated widely during the 1940 war years. "The posters were created to give an authentic propaganda 'vibe,'" said Rogers, whose work is influenced by early to mid-century poster design. All the lettering and imagery was created by hand and airbrushed to give the posters a workmanlike appeal with underlying strength, characteristics conveyed by the angular imagery, bold typeface, and basic color palette.

PROJECT: Dos Equis Beer "Viva La
Revolución!" Posters
CLIENT: Dos Equis Beer
DESIGN FIRM: Heart Times Coffee Cup
Equals Lighting
ART DIRECTOR: Bobby Woods
DESIGNER/ILLUSTRATOR: Paul Rogers

Surprisingly, sometimes a printed piece that is out of registration works. When? When it is designed to mimic the out-of-registration matchbook covers of the 1940s, which is exactly what Michael Doret set out to do with this holiday greeting card, which also features simple lettering and illustration.

PROJECT: "What a Wonderful World!" Holiday Greeting Card
CLIENT: Michael Doret
DESIGN FIRM: Michael Doret Graphic Design
ART DIRECTOR/DESIGNER/ILLUSTRATOR: Michael Doret

PROJECT: People & Arts Channel Travel Diary/Scrapbook
CLIENT: Discovery Networks
DESIGN FIRM: Turkel Schwartz & Partners
ART DIRECTOR: Jojo Milano

The doodles, architectural sketches, European influenced typestyle, and photos all build upon the image of a scrapbook of the 1940s era—in this case, a travel diary created to promote the Discovery Networks' People & Arts channel.

PROJECT: Johnny Cash, The Man in Black Brochure

CLIENT: Recording Industry Association
of America (RIAA)

DESIGN FIRM: Recording Industry Association
of America

ART DIRECTOR/DESIGNER/COPYWRITER: Neal Ashby

PRINTER: Noel Printing

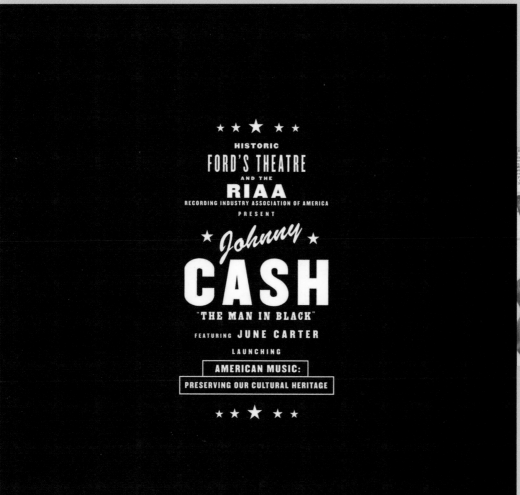

"(I) wanted to create the old wood block printing look used in the 1940s and 1950s, Johnny Cash's formative years," said Neal Ashby, who brought this brochure for the country singer's performance at the historic Ford's Theater to life. "The stacked construction of the type in different weights, along with single illustrations, such as stars, creates a look of Nashville's advertising posters" of the era. To create the brochure, Ashby relied upon early rock, rhythm and blues, as well as country music posters for inspiration.

"This was a time when aviation was innovative, new, exciting, and inspiring," said Harold Riddle of the video packaging he designed and illustrated for Time-Life Video's series, *The Century of Flight*. "The design had to attract a male audience, fifty-plus years old. The attitude: adventuresome, Americana, loyalty, and patriotism. To bundle all of these attitudes into a single, cohesive design, Riddle hand-rendered the typography used for the title of the series and relied on a color palette of muted shades, including khaki and navy that was typical of the era. For the illustrations, Riddle sought inspiration from the silk-screened posters of the twenties and thirties.

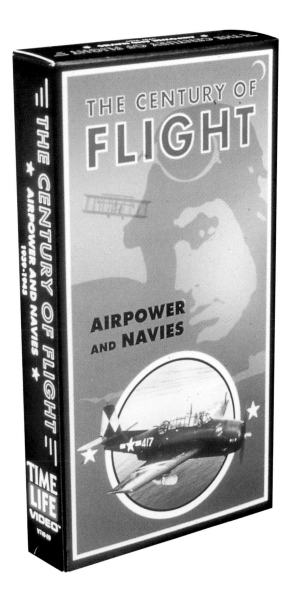

PROJECT: *The Century of Flight* Video Series

CLIENT: Time-Life Video

DESIGN FIRM: neo design

ART DIRECTORS: Harold Riddle, Laura McNeil (Time-Life Inc.)

DESIGNER/ILLUSTRATOR: Harold Riddle

PHOTOGRAPHERS: various

PROJECT MANAGER: Pu-mei Leng

PROJECT: Kansas City Blues & Jazz
Festival Poster
CLIENT: Kansas City Blues & Jazz Festival
DESIGN FIRM: Muller & Company
ART DIRECTOR: John Muller
DESIGNER: Jane Huskey

Kansas City Blues & Jazz was in its prime during the
1940s, so to celebrate its upcoming festival, designers
opted to recreate the mood and atmosphere of its
heyday with a 1940s-era poster design. The Muller
& Company team researched archives of black
performers of the day to find authentic photography,
which when integrated into the period layout,
combines to make a very prominent and eye-catching
poster that really makes the sale.

DESIGN FIRM: Shields Design
ART DIRECTOR: Charles Shields
DESIGNERS: Charles Shields,
Laura Thornton

Greeting Card Design

Shields Design mimics the look of holiday greeting cards of the thirties and forties in its "Happy Holiday" card and played up the wealth of new toys introduced during the 1950s with its greeting card inspired by that decade. As graphic design changed with each succeeding decade— along with color palettes and typefaces—so did greeting cards. Early cards of the twentieth century featured a lot of engraving and Victorian-inspired holiday themes. Today, cards are heavily embossed and often foil-stamped, while their matching envelopes are foil-lined.

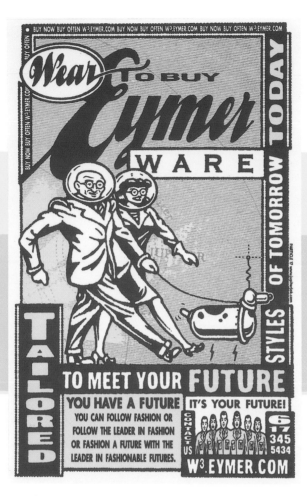

PROJECT: Eymer Design, Inc.
Self-Promotion Posters

CLIENT: Eymer Design, Inc.

DESIGN FIRM: Eymer Design, Inc.

ART DIRECTOR: Douglas Eymer

DESIGNER: Bruce Macindoe

ILLUSTRATOR: Mark Fisher

COPYWRITERS: Doug Eymer,
Mark Fisher, Bruce Macindoe

PRINTER: Sam Johnson & Son

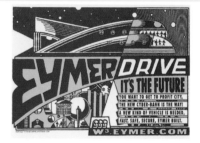

These two self-promotional posters titled "Eymer Ware" and "Eymer Drive" demonstrate the off-beat sense of humor and creative approach of Boston's Eymer Design, while also showcasing a design style typical of the late thirties and early forties, not to mention the frequent, albeit inaccurate, foretelling of what life in "the future" might entail. The color palettes are characteristic of the era: muted shades and atypical color combinations. The line work in the posters has a rough edge, intentionally unsophisticated and rendered with a jagged stroke, to mimic the print quality of posters from the period that were typically printed on low-grade pulp. "The lines were not sharp or sophisticated, but they contained a charm lacking in the ultra-crisp printers of today," said Douglas Eymer.

The Eymer Ware poster features a rendition of the "Ideal Man" and "Ideal Woman," images that were commonly seen in the forties, while the Eymer Drive poster spotlights a cityscape, complete with bubble-shaped architecture dreamed up by the comic book artists of the 1930s.

PROJECT: Pacific Starlight Dinner
Train™ Logo
CLIENT: BC Rail Ltd.
DESIGN FIRM: Wasserman
& Partners Advertising Inc.
ART DIRECTOR: Graham Livingstone
HAND LETTERING: Ivan Angelic
(Hoffmann Angelic Design)

Nightclubs, ballrooms, and dance clubs provided entertainment for
the masses during the 1930s and 1940s, when big bands, swing, and
cocktails were part of a city's nightlife. Because railway dining cars
were equally luxurious and popular during this time (and are virtu-
ally non-existent today), the look and feel of the dinner club was
chosen to set the stage for the Pacific Starlight Dinner Train™. The
hand-rendered lavender type spelling Starlight is often printed in a
metallic silver to represent the metal of a train. All together, the logo
combines both elegance and nostalgia for an era long-gone.

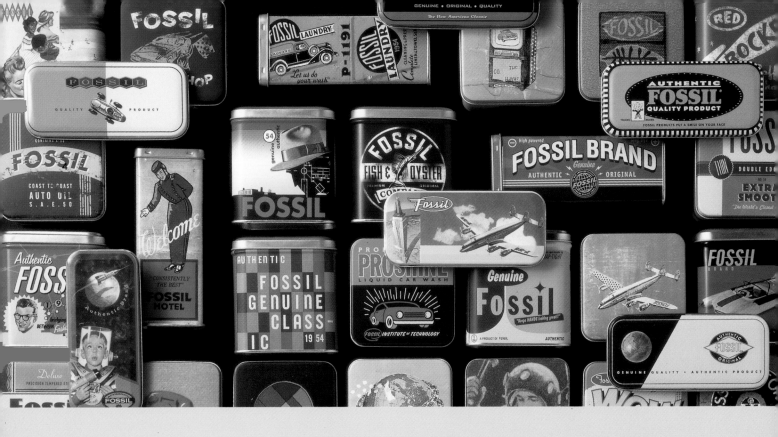

Fossil, a maker of contemporary fashion watches, has made its name by packaging its product in retro-style tins, reminiscent of the tins widely used for all sorts of packaging in the early- to mid-century. While the design team at Fossil created these tin designs recently, they are all historically accurate to the tin packaging of old—incorporating the colors, typestyles, and imagery that made tins that one wanted to save. In turn, old tins today, particularly those where the vivid colors and pictorials are intact, fetch commanding prices among collectors. Those that can't afford the real thing can enjoy the next best thing in Fossil's expertly crafted packaging.

Tin Packaging of the Early Century

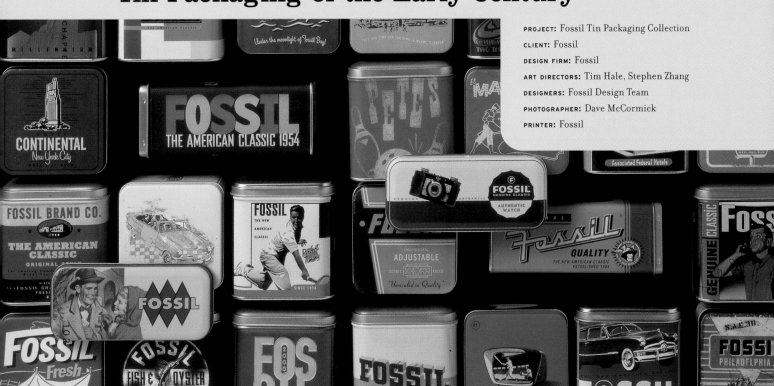

PROJECT: Fossil Tin Packaging Collection
CLIENT: Fossil
DESIGN FIRM: Fossil
ART DIRECTORS: Tim Hale, Stephen Zhang
DESIGNERS: Fossil Design Team
PHOTOGRAPHER: Dave McCormick
PRINTER: Fossil

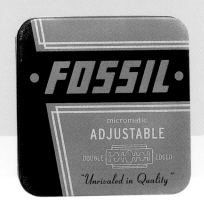

PROJECT: Fossil Razor
Blade Tins
CLIENT: Fossil
DESIGN FIRM: Fossil
ART DIRECTORS: Stephen Zhang,
Clay Reed
DESIGNER/ILLUSTRATOR/COPYWRITER:
Jonathan Kirk
PRINTER: Fossil

Fossil, known for its innovative packaging that perfectly
highlights the retro brand image it projects for its line of
fashion watches, designers called upon typography and a
muted color palette of the 1940s to replicate the style of
razor blade tin packaging of the era. Fossil, a company that
has made its name with vintage looks, uses various styles
of the past to present its watches with a contemporary flair.
The watches and the tins have become collectible to the
point that buyers want to have dozens, not just one.

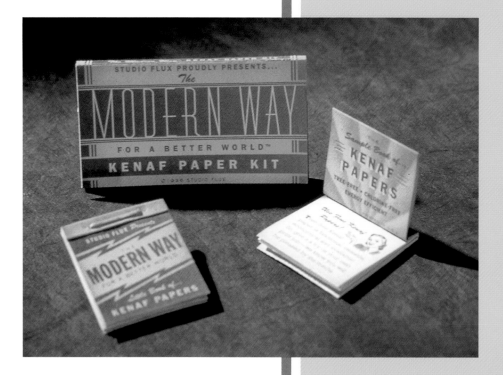

This paper kit, the shape of which is based on old cigarette paper packaging, has the streamlined look of locomotives of the 1940s along with the dusty, unsaturated color palette characteristic of the time. The colors are accented by thin and tall Art Deco-inspired type, while the rays, lines and bands, clip art, and language are all true to the era.

"At this period in time, people were enthralled with the future and how new technologies were going to completely transform their lives," said John J. Moes, of the Modern Way Kenaf Paper Kit. "We are again at a point where new technologies are going to revolutionize the world, this time in order to make our practices sustainable. We wanted to tap into that optimism and belief that the future is going to be better, and dispel the myth that being environmental always means giving up something. Kenaf paper is a better paper than tree-fiber based paper all around, and its good for the environment, too."

PROJECT: Modern Way Kenaf Paper Kit
CLIENT: Studio Flux
DESIGN FIRM: Studio Flux
ART DIRECTOR: John J. Moes
DESIGNERS: John J. Moes, Holly A. Utech
ILLUSTRATOR: John J. Moes
PRINTER: A.G. Johnson Printing

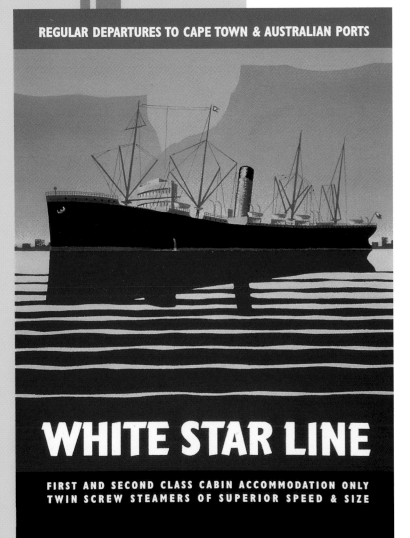

PROJECT: White Star Line Poster
CLIENT: Immigration Museum–
Melbourne, Victoria, Australia
DESIGN FIRM: Beattie Vass Design Pty Ltd.
ART DIRECTORS: Tom Beattie, Giota Vass
DESIGNER: Tom Beattie
ILLUSTRATOR: Bill Wood (Bill Wood Illustration)

Australian illustrator Bill Wood rendered
this White Star Line poster in acrylics and
gouache on conson paper. Using his vibrant
illustration, designers dropped in the type
to create a poster authentic to the era of the
great ocean liners—virtually undisputed as
purveyors of luxurious travel at its best.

PROJECT: Bengie's Drive-In
Theatre Posters
CLIENT: Bengie's Drive-In Theatre
DESIGN FIRM: Johnny V Design
ART DIRECTOR/DESIGNER/ILLUSTRATOR:
Johnny Vitorovich
PHOTOGRAPHER/COPYWRITER:
Johnny Vitorovich
SCREEN IMAGE: Archive Films
PRODUCTION: Regina Esposito
PRINTER: Color Craft of Virginia

the 1950s

Following the war years and five years of reconstruction, the world was ready to look forward and the future never looked brighter than it did in the 1950s. Optimism and prosperity reigned. What we think of the ideal family—mother, father, son, and daughter—have since become an icon identifying the era. Couples moved to the suburbs to build their dream homes and families after the war. The economy was good and they could afford a new car, a television set, and fancy kitchen appliances to make mom's job easier.

They could also afford vacations, and they took to the road in the big way. Passion for cars and the mobility they provided, gave rise to numerous industries—car washes, motels, and drive-in theaters and restaurants—which ultimately spurned the birth of what we now know as fast-food. Families could now hit the road for a vacation trip and find inexpensive eateries, entertainment, and lodging all easily serviced from their car.

Despite the war, the world was still relatively naive. Days were cheery and so was the music. Sprightly tunes and equally light motion pictures were popular. At one end of the spectrum, movies became grittier—such as *A Streetcar Named Desire*, while simultaneously motion picture makers offered plenty of laughs and thrills (as evidenced by the science fiction movies that dominated the drive-ins). Film-makers would give the public what it wanted as television threatened to bankrupt the industry.

As the decade wore on, the music took on an edge that was considered too radical by conservative tastes. But rock and roll was here to stay, and its impact, born of the fifties, was to have a lasting effect on decades to come.

head
lines OF THE 1950s

On June 2, 1953, the coronation of Queen Elizabeth II took place in Westminster Abbey.

British athlete Roger Bannister ran the mile in less than four minutes (3:59:4) on May 6, 1954, launching him into history as the first person to break the four-minute mile.

The USSR launches Sputnik 1 October 4, 1957.

In the U.S., tension mounts in the Southern states as officials attempt to desegregate schools in 1958, giving rise to the Civil Rights movement.

On January 3, 1959, Fidel Castro became prime minister of Cuba.

entertainment

Method acting, an acting technique based on living the part in which the actor loses himself or herself completely in the role, becomes popular and is advocated by such stars as Marlon Brando. Drive-in theaters become the rage—providing inexpensive family entertainment as well as an inexpensive getaway for couples. Science fiction thrillers were popular as evidenced by the *Creature from the Black Lagoon* (1954) and *The Blob* (1958).

Rock and Roll music was born, led by young "radical" performers such as Elvis Presley, Buddy Holly, Bill Haley, and others.

Television programming boomed and people stayed home for their entertainment, watching such programs as the *Milton Berle Show*, *The Honeymooners*, and *I Love Lucy*. With many people staying home, a new meal was born that was easy to prepare and convenient to eat in front of the set: the TV dinner.

New Wave, which refers to a pop music movement from the early 1970s that included punk rock and offbeat arrangements, and also heavy rock, was first used to describe a new movement in literature and the cinema that originated in France, *la Nouvelle vague*, in the late 1950s.

Skiffle, a kind of makeshift jazz music, came into fashion during the mid-50s, and included guitars, banjos, mandolins and a number of homemade instruments such as a washboard and paper-and-comb. The repertoire was largely folk music with a beat.

Hula hoops and poodle skirts were among the fads born in the 1950s.

art
and architecture

Paolozzi, Johns, and Rauschenberg were among the pioneers of Pop Art, an artistic movement that arose in the 1950s using photographs, strip cartoons, and advertisements as subjects, which were often enlarged and painted surrealistically in garish colors. Brutalism, a movement in modern architecture starting in the 1950s, aimed at the straight-forward often rough, use of materials brought about by architects Le Corbusier and Mies van der Rohe.

technology and science

Color television was first introduced in the U.S. in 1951. Seven years later in April 1958, the first stereo disc records were sold in the U.S. The first cubic zirconia stones debuted on November 17, 1959 when De Beers, diamond firm in South Africa, announced that synthetic diamonds had been made.

Men went back to work after the war years and women returned to the home, bringing about an onslaught of femininity in all things as increasingly more products and services were marketed to women as homemakers: home appliances, cars, and fashion. Pink, almost universally regarded as the epitome of femininity was a popular color, but its significance went much deeper than aesthetics after the war weary, rationed, and subdued decade of the forties. After so much deprivation in everything, including color, pink's bright liveliness signified optimism and came to represent what the decade of the 1950s was all about.

Color **Cues:** 1950s

Pink appeared in numerous variations-from peachy-pink (PANTONE 1765) to pale pink (PANTONE 183), medium pink (PANTONE 190), powder pink (PANTONE 196), and cool pink (PANTONE 203). Shocking pink, popular in the 1930s, made a comeback in a new incarnation: hot pink (PANTONE 212), and cosmetics companies like Revlon ran advertising featuring the entire product range in hot pink.

"Think pink" became a catch phrase and even Hollywood turned pink, featuring an entire scene in the motion picture *Funny Face*, starring Fred Astaire and Audrey Hepburn, in that shade. When pink (PANTONE 196) needed a partner, turquoise blue (PANTONE 304) rose to the occasion as its perfect complement—the colors were all part of a trend toward pastelling, and appeared on everything including two-toned cars such as Studebakers and Nash Ramblers. Other light cheery shades gaining momentum in the 1950s color palette include pistachio (PANTONE 365) and bright yellow (PANTONE 1345).

Amid a rainbow of pastels, black re-emerged as an influential color; it became chic to wear black and it appeared once again as the black cocktail dress and as skinny Capri slacks that looked great when accented with brightly colored tops. Technology was making more and more vibrantly colored dyes possible, and the decade saw the beginnings of fluorescent colors. Lime green (PANTONE 375) was introduced in the 1950s. This introduction was followed by other bright colors—born out of the beginnings of Rock n' Roll —yellow (PANTONE 109), raspberry (PANTONE 213), fuchsia (PANTONE 245), purple (PANTONE 266), teal (PANTONE 3272), and Kelly green (PANTONE 368).

Orange (PANTONE ORANGE 021) was also seen for the first time—and marked the first indication of the psychedelic era that was to come in the 1960s.

Type
1950s
Tracker:

Influences

With the war over, more typesetting was being done. European typefaces that were popular in the 1930s, were discovered during the war, and once the type foundries started up production again, the U.S., in particular, started importing many fonts from overseas. Consequently, several of the faces that debuted in the U.S. in the fifties, had actually been in use throughout the 1930s and 1940s in Europe.

Characteristics

In contrast to the flamboyant colors and sprightly atmosphere of the 1950s, typefaces of the era were pretty austere. In the 1960s and 1970s, fonts livened up as part of an Art Nouveau and Art Deco revival and there was a surge in display type when phototypesetting came into being, but in the meantime, typefaces were pretty bland.

Fonts of the 1950s

Among the popular faces were Caledonia, a text typeface; Spartan and Tempo, neither of which are available today in digital form, were created to imitate Futura, a German font used widely in the twenties and thirties; Comstock was used a lot but isn't available today as was Times New Roman, which was designed in the 1930s in the United Kingdom and was imported by the U.S. in the fifties.

Typefaces owned and provided by Agfa Monotype.

Fonts you probably own that evoke the era:

T

Times New Roman
abcdefghijklmnopqrstuvwxyz1234567890
ABCDEFGHIJKLMNOPQRSTUVWXYZ

T

Corvinus Skyline
abcdefghijklmnopqrstuvwxyz1234567890
ABCDEFGHIJKLMNOPQRSTUVWXYZ

T

PL Latin Bold
abcdefghijklmnopqrstuvwxyz1234567890
ABCDEFGHIJKLMNOPQRSTUVWXYZ

T

Bodoni
abcdefghijklmnopqrstuvwxyz1234567890
ABCDEFGHIJKLMNOPQRSTUVWXYZ

T

Futura
abcdefghijklmnopqrstuvwxyz1234567890
ABCDEFGHIJKLMNOPQRSTUVWXYZ

T

Futura Light
abcdefghijklmnopqrstuvwxyz1234567890
ABCDEFGHIJKLMNOPQRSTUVWXYZ

CONTEMPORARY
design
looks back

PROJECT: Chicago Volunteer Legal Services
1999 Annual Report
CLIENT: Chicago Volunteer Legal Services
DESIGN FIRM: Lowercase, Inc.
ART DIRECTOR/DESIGNER: Tim Bruce
PHOTOGRAPHER: Tony Armour
COPYWRITER: Margaret Benson
PRINTER: H. MacDonald printing

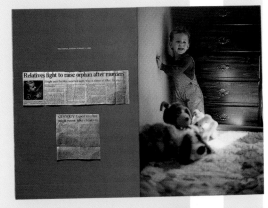

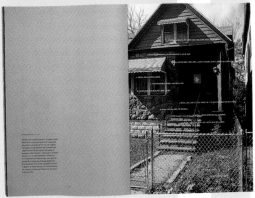

"In the 1950s, the U.S. was still basking in the victory of World War II; the peacetime economy grew and prosperity infiltrated the middle-classes. Entire neighborhoods sprang up overnight. People were raised in tight-knit, family-oriented urban communities," said designer Tim Bruce, when asked why the 1950s era was chosen as the backdrop for this 1999 annual report, where community and volunteerism plays a major role.

To reflect this period, Bruce used an oversized layout and a clean cover with a linear pattern to reflect the sleek modern designs of the 1950s from the Air Stream campers to Cadillacs. Inside, the sepia photographs and no-nonsense type increase the feeling of nostalgia. The content of the photos is also noteworthy for their ability to juxtapose modern-day images with those of a by-gone era. The "telephone, postage meter, desk chair, and files—though used today—seem somewhat quaint as compared to the high-tech image of office spaces we have today," said Bruce.

PROJECT: United Friendly Insurance
Direct Mail

CLIENT: United Friendly Insurance

DESIGN FIRM: HGV Design Consultants

ART DIRECTOR/DESIGNER: Pierre Vermeir

ILLUSTRATOR: Paul Cemmick

PRINTER: The Colourhouse

To drive home the message that vacationers in the
United Kingdom need travel insurance even if they
aren't traveling abroad, HGV Design Consultants
created a direct mailer featuring a series of holiday
postcards. Designers borrowed the illustration style
of Donald Gill, who made a name for himself in the
fifties with his "cheeky" English seaside postcards
featuring slapstick comedy situations. Today, the
colorful cards are memorable and campy.

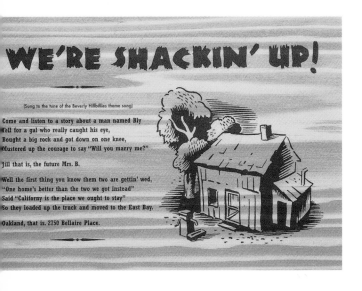

American country and western music—from the 1950s—sets the scene for this Weddin' invitation and Movin' announcement. The choice is appropriate since the bride and groom were fans of country music and an old honky-tonk bar was chosen to host the reception. The design pays homage to the Grand Ol' Opry posters of the forties and fifties. "The use of heavy slab serif typefaces and imitation wood grain …is heavily influenced by this time period when television and movies were redefining the look of westerns and country music," said Chris Rooney.

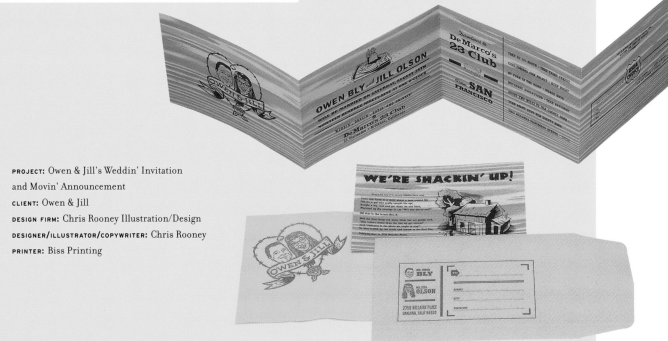

PROJECT: Owen & Jill's Weddin' Invitation and Movin' Announcement

CLIENT: Owen & Jill

DESIGN FIRM: Chris Rooney Illustration/Design

DESIGNER/ILLUSTRATOR/COPYWRITER: Chris Rooney

PRINTER: Biss Printing

What period has most influenced your personal style of design?

"My sources of inspiration tend to capitalize on a rich American design vernacular that existed from the mid-forties through the mid-sixties. There is a certain timeless combination of naiveté, playfulness, and artificialness that was acceptable then that still strikes a chord today." —*Chris Rooney, Chris Rooney Illustration/Design*

STEREOPHONIC

WELCOME TO THE RIAA

SWINGLOUNGE

HEY CATS! 1998 WAS A REAL GAS FOR THE RIAA! WE WERE REALLY COOKIN', MAN!
SO COME JOIN US AS WE SWIRL COLD MARTINIS AND TWIRL OUR SWINGING PARTNERS
ON THE DANCE FLOOR. COME TO THIS PARTY AND YOU HAVE ARRIVED!

MUSIC BY THE DELEGATES

In 1998, RIAA used this invitation to promote its "Swing Lounge," a late-1950s themed party. "We wanted the era best known for martinis and bachelor pads," said designer Neal Ashby, who created the invitation using RIAA's original logo from the 1950s along with typography and imagery of the era including everything from cocktails and cars to the upholstered lounge furniture of the decade.

PROJECT: Swing Lounge Invitation

CLIENT: Recording Industry association of America (RIAA)

DESIGN FIRM: Recording Industry Association of America

ART DIRECTOR/DESIGNER/COPYWRITER: Neal Ashby

PRINTER: Noel Printing

PROJECT: Coolsville Logo

CLIENT: Coolsville Records

DESIGN FIRM: Michael Doret Graphic Design

ART DIRECTOR: Brad Benedict

DESIGNER/ILLUSTRATOR: Michael Doret

Coolsville, a lounge-oriented record label, is treated to the 1950s design aesthetic. Turquoise, one of the decade's most popular colors is prominent, and the layout and choice of type are whimsical, which mirror the optimistic outlook of the U.S. during the post-war decade.

Products and Packaging Skewed to Entertainment

The 1950's mobile and television-oriented society prompted new industries to spring up virtually overnight. Drive-ins and motels are just some of the innovations that took the world by storm during the decade. Food and its packaging also changed. Food had to be eaten on the go, in the car, and in front of the TV. Hence, the development of the TV dinner—pre-cooked meals that only had to be heated before serving. The packaging was equally innovative with a compartmentalized tray featuring the main course, side dishes, and dessert—all easy and convenient to enjoy while watching *I Love Lucy*.

Here, EAI uses the TV dinner packaging concept to give flavor and spice to Gamut Media's TV production services.

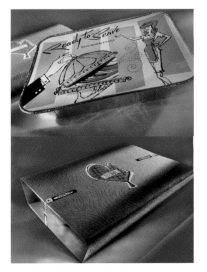

PROJECT: Gamut Media Box

CLIENT Gamut Media

DESIGN FIRM: EAI

CREATIVE DIRECTORS: Phil Hamlett, Matt Rollins

DESIGNER: Todd Simmons

ILLUSTRATOR: Edward Fotheringham

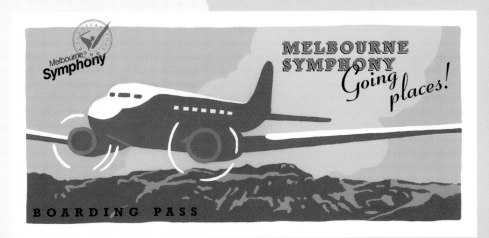

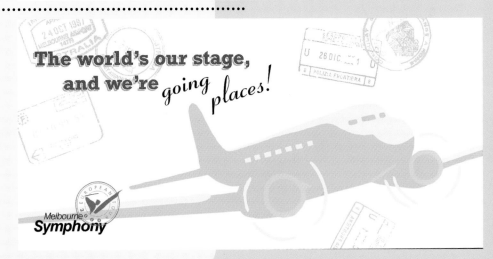

The Melbourne Symphony wanted a visually exciting identity to promote its first international tour. The promotion had to encourage sponsor support and work equally well as print advertising and program pages. Designer Andrea Rutherford latched onto the travel theme and created a promotion using a colorful illustration to spotlight a boarding pass in a 1950s design, the likes of which we don't see anymore. She created a new logo in keeping with the travel theme and added luggage labels and boarding pass stamps to round out the design.

PROJECT: Melbourne Symphony Boarding Pass

CLIENT: Melbourne Symphony

DESIGN FIRM: Smart Works Pty. Ltd.

ART DIRECTOR/DESIGNER/ILLUSTRATOR: Andrea Rutherford

COPYWRITER: Alison Alexander

PRINTER: Bambra Press

A 1950s diner waitress serves up "the works" in this party invitation from Smart Works. "The choice of paper, color, and imagery all helped us emulate the 1950s diner period and lifestyle," said designer Andrea Rutherford. "The clever play on words are reinforced by the pictures and type treatment."

PROJECT: The Smart Works Invitation

CLIENT: Smart Works Pty. Ltd.

DESIGN FIRM: Smart Works Pty. Ltd.

ART DIRECTOR: Zan Shadbolt

DESIGNER: Andrea Rutherford

COPYWRITER: Alison Alexander

PRINTER: McKellar Renown

When Kristin Lennert, a Sayles Graphic Design staff member, asked John Sayles to design the invitations for the events surrounding her wedding, Sayles went for the unusual. Hinging the theme on the slogan, "A Match Made In Heaven," Sayles used a matchbook configuration for everything from the actual invitation to the thank-you notes. Hand-rendered type, a cheerful, albeit untraditional wedding color palette of white, yellow and purple, and slogans found on diner matchbooks of the fifties all contribute to the optimistic mood prevalent of the 1950s era—which is surprisingly fitting for a wedding.

PROJECT: "A Match Made In Heaven" Wedding Invitation

CLIENT: Kristin Lennert & Andrew Murra

DESIGN FIRM: Sayles Graphic Design

ART DIRECTOR/DESIGNER/ILLUSTRATOR: John Sayles

COPYWRITER: Kristin Lennert

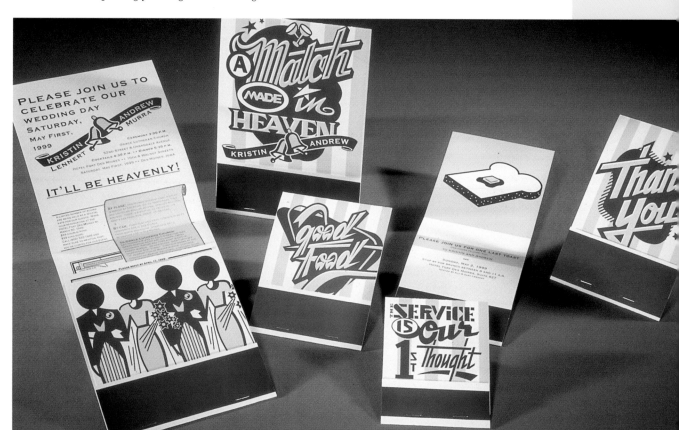

PROJECT: Pillsbury Madison
& Sutro Ad Series

CLIENT: Pillsbury Madison & Sutro

DESIGN FIRM: Greenfield Belser Ltd.

ART DIRECTOR: Burkey Belser

DESIGNER: Kristen Mullican-Ferris

COPYWRITER: George Kell

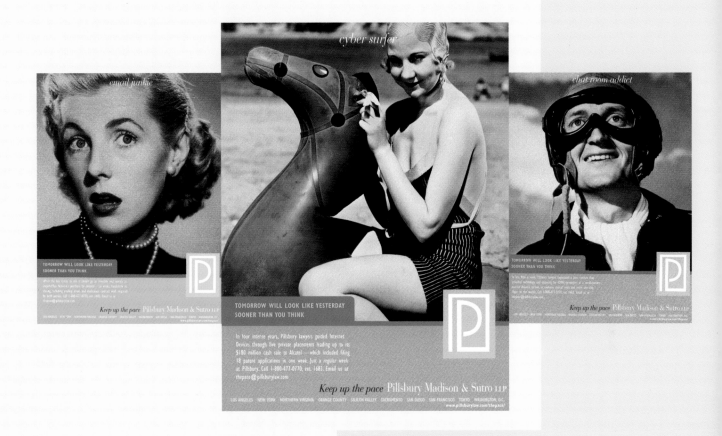

The law firm of Pillsbury Madison & Sutro wanted to target entrepreneurs in Silicon Valley, California with a new series of advertisements. When Greenfield Belser Ltd. dug into the job, they opted to set the ads in the late-1950s/early-1960s because the earliest memories of the intended audience were of their parents during that era. To execute the plan, designers chose three subjects from stock black-and-white photography that reflected the hairstyles and clothing of the era. These images of "more innocent" times contrast nicely with today's high-tech monikers assigned to each subject—the housewife in pearls: an email junkie.

PROJECT: Q101 Jamboree '99 Promotion

CLIENT: Q101 Radio

DESIGN FIRM: Segura Inc.

ART DIRECTOR: Carlos Segura

DESIGNERS: Carlos Segura, Laura Husmann,
Tnop, Sara Ploehn

ILLUSTRATOR: Alex Wald

COPYWRITER: Q101 Radio

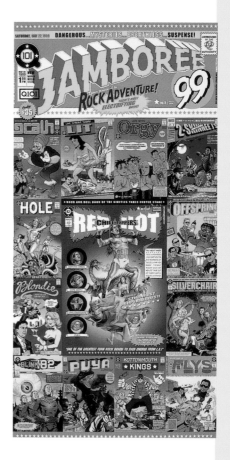

The imagery of this promotion for a Chicago radio
station may be a bit edgier than it was in the fifties,
but the illustration style, color palette, and headline
type styles mirror that made famous by comic book
illustrators during that decade. Designers created a
different comic book cover for each of the bands at the
station's Jamboree '99 event, and compiled them all
into a single promotional poster.

Comics, despite their light-hearted approach, provide a very accurate visual timeline of graphics during the twentieth century. Early cartoons were generally created for political editorials and leading the trend was Thomas Nast, considered by many as the greatest cartoonist of the early century, noted for his crusades against political corruption. He is also the man responsible for popularizing the symbols that denote the major political parties in the U.S.—the Republican elephant and the Democratic donkey.

Rodolphe Töpffler, a Swiss cartoonist, was the first to divide his drawings into frames where the pictures were explained with a running narrative that told the story below each frame. These picture stories subsequently gained popularity in Germany, where Wilhelm Busch became noted for his Max und Mortiz cartoons. Ultimately, at the turn of the century, U.S. cartoonists developed the comic strip as we know it today as a result of the rivalry between competing newspapers run by Joseph Pulitzer and William Randolph Hearst.

Non-political cartoon panels became a daily feature in newspapers in the late 1800s and carried into the 1900s featuring regular casts of characters with a continuing storyline that appealed to a broad audience. Following World War I, the comic known as the "gag panel", became a sophisticated trend in cartooning, and was deftly used by *The New Yorker* magazine and *Vanity Fair*, among others.

The 1920s and 1930s gave rise to some of the most time-honored comic strips including Harold Gray's *Little Orphan Annie*, Frank Willard's *Moon Mullins*, Chic Young's *Blondie*, Chester Gould's *Dick Tracy*, and Al Capp's *Li'l Abner*. Action comics originated during the 1930s with such adventure strips as *Tarzan*, *Buck Rogers*, and *Flash Gordon*. Action Comics, which began in 1938, introduced *Superman* to the world, as created by Jerry Siegel and Joe Shuster.

During World War II many comic heroes went to war or fought adversaries at home and worked in war industries. With the dawn of the 1950s, realism entered the comic arena and many comics became quite "intellectual." Some were able to combine satire and still appeal to children and the most notable among this group was Charles Schulz, who debuted his *Peanuts* strip in the 1950s.

The Marvel Comics Group brought back the superheroes in the 1960s to appeal to a teenage audience, including the *X-Men*. During this time, comic strips were being used by pop-art painters in Europe and the U.S., who borrowed details for their paintings.

PROJECT: KBDA Bowl-o-Rama
Holiday Promotion

CLIENT: Kim Baer Design Associates

DESIGN FIRM: Kim Baer Design Associates

ART DIRECTOR: Kim Baer

DESIGNER/ILLUSTRATOR/COPYWRITER:

Jim Baehr

The team at Kim Baer Design Associates wanted something different for their upcoming holiday party invitation—something fun and carefree. The desired ambience led them to recreating the aura of the 1950s—and specifically, the bowling alleys of the day. "All aspects of the design reflect the happy, carefree utopian feeling of post-war America in the fifties. A playful fifties typeface, muted color palette, overuse of background patterns, and amoeba-like scientific shapes encourage the aesthetic," explained Kim Baer. The graphics played out on the party invitation, name tag, award certificates, and team T-shirts.

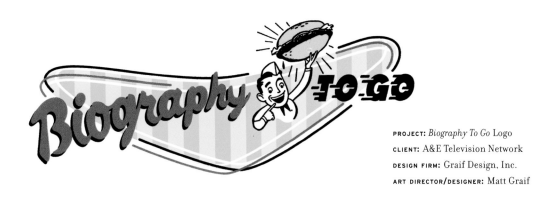

PROJECT: *Biography To Go* Logo

CLIENT: A&E Television Network

DESIGN FIRM: Graif Design, Inc.

ART DIRECTOR/DESIGNER: Matt Graif

The popularity of the automobile prompted numerous businesses that catered to the new, mobile society, including drive-in theaters, motels, and drive-in restaurants, especially those offering "fast food" such as hamburgers. Graif Design sought inspiration from the latter when A&E Television Network, purveyor of the hour-long program *Biography*, wanted a custom logo that would appear at the beginning of each show profiling one the big food giants of the 1950s.

"The type—script styles of the fifties—and the background shape clearly reflects shapes used during the period in architecture and design," said Matt Graif.

This self-promotional guide with client tips for using the R.M. Hendrix Design Company comes straight out of the 1950s beginning with its pistachio-colored leatherette cover with red/orange accents to its very utilitarian black and red interior layout. "When I first began my business, I realized the need for a client manual," said Michael Hendrix. "This booklet explained the functions of a graphic design studio and the expectations I had for my clients. Because I am a collector of machinery manuals, I naturally wanted to make my own."

PROJECT: R.M. Hendrix Design Company
Client Manual

CLIENT: R.M. Hendrix Design Company

DESIGN FIRM: R.M. Hendrix Design Company

ART DIRECTOR/DESIGNER/ILLUSTRATOR:
Michael Hendrix

PHOTOGRAPHER: James Madden, PhotoDisc

COPYWRITER: Michael Hendrix

PRINTER: Paradigm Printing

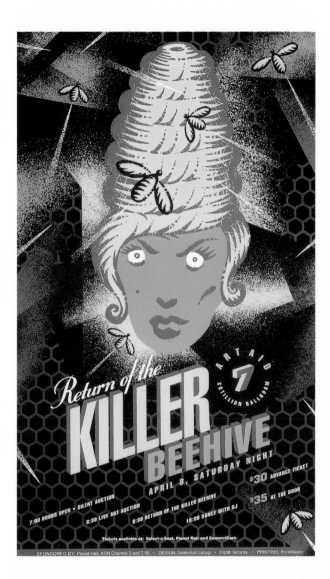

In movie houses, and especially drive-in theaters during the 1950s, a new kind of movie was making headlines as wild science fiction story lines won popularity, particularly among younger movie-goers. So when Planet Hair signed on as a sponsor of ConnectCare's ArtAid 7 benefit, the theme for the event was born. Once the event's name was decided upon—Return of the Killer Beehive—the design style fell into place. The poster is circa late-fifties in style as evidenced by its emulation of the movies' sci-fi titles and its color palette, featuring the 1950s all-new lime green, bold purple, and yellow, colors typical of the pre-psychedelic era.

PROJECT: Return of the Killer Beehive ArtAid 7 Poster

CLIENT: ConnectCare

DESIGN FIRM: Greteman Group

ART DIRECTOR: Sonia Greteman

DESIGNERS: Sonia Greteman, James Strange

ILLUSTRATOR: James Strange

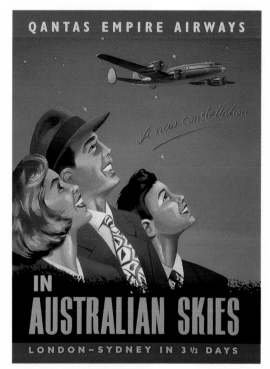

This poster promotes trans-world flight on Quantas Empire Airways between London and Sydney in just three and a half days—a remarkable speed record that allowed families in the 1950s to begin considering air travel. Bill Wood's illustration shows just how innovative this concept was at the time, dazzling the "ideal fifties family" during a time when people actually dressed up to travel.

PROJECT: In Australian Skies Poster

CLIENT: Immigration Museum-Melbourne, Victoria, Australia

DESIGN FIRM: Beattie Vass Design Pty Ltd

ART DIRECTORS: Tom Beattie, Giota Vass

DESIGNER: Tom Beattie

ILLUSTRATOR: Bill Wood (Bill Wood Illustration)

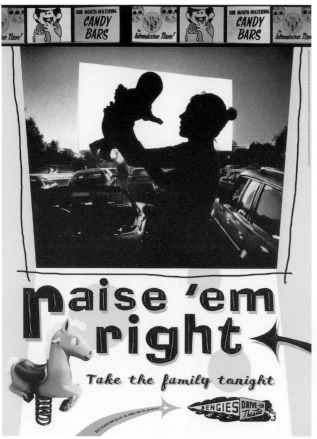

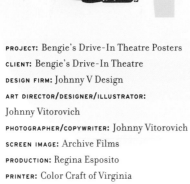

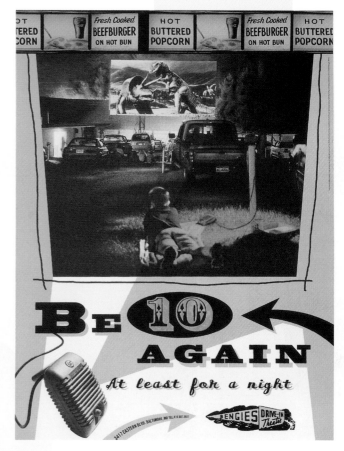

PROJECT: Bengie's Drive-In Theatre Posters

CLIENT: Bengie's Drive-In Theatre

DESIGN FIRM: Johnny V Design

ART DIRECTOR/DESIGNER/ILLUSTRATOR:
Johnny Vitorovich

PHOTOGRAPHER/COPYWRITER: Johnny Vitorovich

SCREEN IMAGE: Archive Films

PRODUCTION: Regina Esposito

PRINTER: Color Craft of Virginia

To promote Bengie's Drive-In Theatre, designer Johnny Vitorovich hearkened back to the mid-to late-1950s when drive-in theaters were first introduced and enjoyed an overwhelming surge in attendance as family entertainment because they provided a great setting for a car date. "I believe the typography and color palette best reflect this period," explained Vitorovich. "Careful scrutiny went into the selection criteria for all the type-faces in all three posters. Type from posters that were produced in the middle to late-1950s and even early sixties was influential to the type sensibility—especially (that of) theater posters."

What period has most influenced your personal style of design?

"It would have to be a combination of the 1930s (posters, WPA), a hint of the fifties, and a touch of contemporary."
—*Johnny Vitorovich, Johnny V Design*

CLASSIC
animation
and pop icons

1 x 30 minutes
A U.S. network TV perennial for more than
20 years, *Frosty the Snowman* is now an American
holiday classic. When Frosty is accidentally
brought to life by a magical silk hat, he must
weather a storm of adventures – not to men-
tion the dastardly plans of an evil magician –
before finding safety and happiness at
the North Pole.

FROSTY THE SNOWMAN

1 x 60 minutes
U.S. network TV's longest-running, highest-rated
holiday special follows the adventures of young
Rudolph one stormy Christmas Eve. Shunned by
the other reindeer because of his red nose,
Rudolph becomes a hero when he uses his nose
as a guiding light to help Santa Claus deliver
presents to children all over the world.
Featuring the voice of Burl Ives.

RUDOLPH THE RED-NOSED REINDEER

1 x 60 minutes
Fred Astaire and Mickey Rooney tell the story
of young Kris Kringle, who grew up to be Santa
Claus. Along the way, he saves Christmas from
the evil Burgermeister Meisterburger, who hates
children as well as Christmas. A long-standing
U.S. network classic, this series continues to
win the hearts of children and parents alike.

SANTA CLAUS IS COMING TO TOWN

PROJECT: Golden Books
Product Catalogue
CLIENT: Golden Books
Family Entertainment
DESIGN FIRM: Viva Dolan
Communications and Design Inc.
ART DIRECTOR: Frank Viva
DESIGNERS: Jim Ryce, Frank Viva
COPYWRITER: Doug Dolan
PRINTER: Arthurs-Jones Clarke

Golden Books, the publisher of children's books in the
1950s and 1960s, pays tribute to its heyday in this product catalog
that highlights its diverse library of animated specials, classic television
shows and movies, as well as music. While the catalog itself is designed
exactly as one of its vintage books, the catalog alone provides a nice
retrospective of the classic animated images and pop icons of the
1950s and 1960s that have become rooted popular culture today and
have influenced graphic design.

Here, baby boomers are treated to a trip down memory lane
as they fondly relive the classic animated specials and television
shows that were part and parcel of their childhood courtesy of
Golden Books.

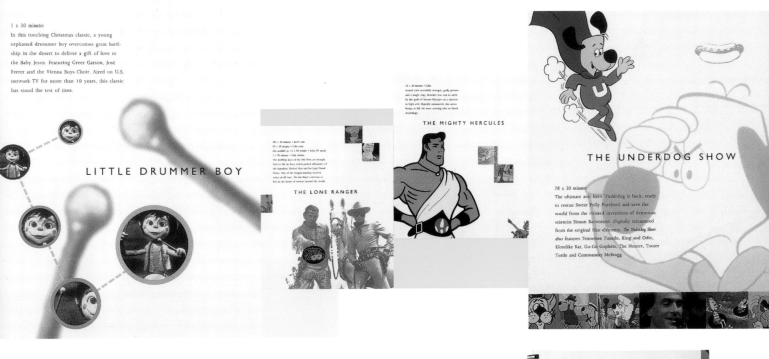

PROJECT: *Therapy?* Screamager CD
CLIENT: A & M Records
DESIGN FIRM: Sunja Park Design
ART DIRECTOR/DESIGNER: Sunja Park
PRINTER: AGI

the 1960s

To say the 1960s was a time of change, experimentation, rebellion, and youth is perhaps an understatement. It was all these things and more. But to describe this decade in a capsule summary is a virtual impossibility, so different are its extremes.

It began much like the 1950s—innocent and naive—it ended with an upturned world where youth rebelled on college campuses, free love reigned, threatening the sanctity of marriage, and drug use and experimentation became so widespread it was thought of as a recreational activity. The divide between children and their parents became so carved out by misunderstanding and miscommunication that it gave rise to the term, Generation Gap.

Women and their roles in society were also changing. Up until the 1960s (with the exception of times of war), women quit working when they married. But Betty Friedan's book, *The Feminine Mystique*, published in 1963, pointed out that many college-educated women did not use their degrees, but went into the homes and devoted themselves to being wives and mothers. Her observation, coupled with that of numerous other outspoken women, advocating women's rights and fighting sex discrimination, made headway and before long statistics showed that from 1960 to the early 1970s the influx of married women workers accounted for almost half of the increase in the total labor force, and working wives were staying on their jobs longer before starting families.

The women's liberation movement was born, some proclaiming hostility to men and burning their bras as a symbol of freedom. Equality between the sexes was the battle cry. Soon women experienced a sexual freedom they never had before—when motherhood became a lifestyle choice rather than an eventual happening with the introduction of The Pill.

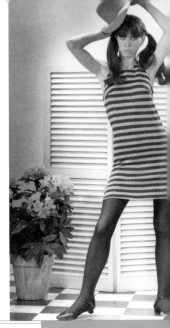

head
lines OF THE 1960s

The Orient Express train ceased its Paris-Bucharest run after 78 years on May 28, 1961. On November 22, 1963 Lee Harvey Oswald assassinated U.S. President John F. Kennedy in Dallas; Vice President Lyndon B. Johnson is sworn in as president.

The Vietnam War begins in 1965. In 1966, the Roman Catholic Church raises the ban that forbade Catholics to eat meat on Fridays. U.S. Civil Rights leader Martin Luther King is assassinated in Memphis, Tennessee April 4, 1968.

May 10, 1968 marked a day of violent clashes between students and police in Paris. More than nine million workers are on strike in France.

Back in the U.S., Robert Kennedy, U.S. senator, is shot on June 25, 1968 and dies twenty-five hours later.

In Iran, an earthquake strikes on August 31, 1968 and results in the loss of more than 30,000 lives.

entertainment

Less is more as proven by the bikini, which made a big fashion statement, but did not appear in U.S. films until 1964. When it was finally allowed, such stars as Raquel Welch and Brigitte Bardot made it look skimpier than it was.

Elvis Presley made a collection of films in the 1960s. By the mid-1960s the code that had governed propriety and the content of films was dissolved and with its demise, nudity (which had been more common in European films) made headlines in U.S. films as well, and was used, some say arbitrarily simply because the code no longer forbade nudity. The trend of nudity in films declined as the novelty wore off by the seventies when it was used with a more "purposeful intent."

Mini-skirts are all the rage in 1966.

art
and architecture

Andy Warhol and Peter Max became popular with artwork that has subsequently come to signify the sixties.

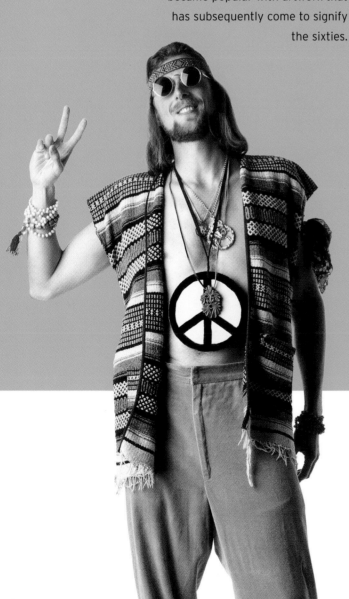

technology and science

The prototype of the supersonic airliner Concorde is shown for the first time December 11, 1967. Chicago's Lake Point Tower, rising 645 feet high (197 meters) becomes the world's tallest reinforced concrete apartment block in 1966.

On July 21, 1969, the Apollo 11 spacecraft lands on the moon and Neil Armstrong becomes the first man to walk on its surface and utters the famous statement, "This is one small step for man; one giant step for mankind."

There was an explosion of color in the 1960s due to new technology that made a range of dyestuffs available to the masses. This innovation, coupled with an entire new range of synthetic fabrics and a renewed interest in cotton fabrics that took dye well, fueled the public's fascination with color that went beyond textiles and finishes to creating unique color combinations in everything from snow boots to raincoats.

Color 1960s
Cues:

Colored pantyhose debuted to complement mini-skirts, and the two appeared in a variety of combinations. Fashion designers Pucci and Mary Quant led this trend, and the result was that color appeared everywhere; items that had previously been black, khaki, or nude, burst onto the scene in never-before seen shades of red (PANTONE 1788), blue (PANTONE 299), yellow (PANTONE YELLOW), and green (PANTONE GREEN).

During the late-1960s, the popularity of the ethnic look inspired color combinations in all walks of life. Blue jeans were paired with Indian tops that sported a riot of colors.

Colorful peasant jewelry, beadwork, and macramé plant hangers and belts were popular. Women started lining their eyes with kohl pencils. The ethnic look gave the masses permission to do things that were widely innovative, and the trend took its color cues from native African, Oriental, and Indian clothing, arts, and crafts.

Meanwhile, the music scene and drug culture brought about the psychedelic era with a fluorescent explosion of color: blue (PANTONE 801 AND PANTONE PROCESS BLUE), lime green (PANTONE 802 AND PANTONE 375), vibrant yellow (PANTONE 803 AND PANTONE PROCESS YELLOW), fluorescent orange (PANTONE 804), fluorescent red (PANTONE 805), fluorescent pink (PANTONE 806), and violet and magenta (PANTONE 807 AND PANTONE PROCESS MAGENTA).

Late in the decade, orange and varying shades of golden yellow generated a stir after appearing on the cover of the Beatles' album *Yellow Submarine*. These warm shades ranged from goldenrod (PANTONE 130) and orange (PANTONE 186) to golden yellow (PANTONE 116) and varying hues of pumpkin (PANTONE 137). This seldom seen color palette rapidly became popular with interior designers. By the early 1970s, these shades could be seen in the very best homes with the latest décor.

1960s

Type Tracker:

Influences

The period was marked by two distinctive styles: a lot of revivals, including Art Nouveau and to a lesser degree, Art Deco period influences. Meanwhile, the whole psychedelic movement generated its own style of typefaces, many of which took their inspiration from Art Nouveau posters and similar graphic type treatments of the Art Nouveau artists.

Characteristics

Typefaces of the 1960s are easy for designers to emulate because there were some very distinctive typefaces used during this period.

Fonts of the 1960s

By far the most popular text typefaces of the period were Helvetica and Times Roman. However, other, more distinctive faces were also used. Unfortunately, while many of the original sixties faces are not available today in digital form, there are some that are revivals of sixties typeface design including display fonts such as Peace, Love, Ray Cruz's Swinger, Pump, Black Boton, Eccentric, plus Art Nouveau revival faces like Skjald, Windsor (which was from the late 1800s that became available in phototype), and M.N. Ortem.

Typefaces owned and provided by Agfa Monotype.

Fonts considered groovy in the sixties include:

PEACE OPEN
ABCDEFGHIJKLMNOPQRSTUVWXYZ1234567890

PEACE OUTLINE
ABCDEFGHIJKLMNOPQRSTUVWXYZ1234567890

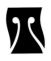

PEACE SOLID
ABCDEFGHIJKLMNOPQRSTUVWXYZ1234567890

LOVE OPEN
ABCDEFGHIJKLMNOPQRSTUVWXYZ1234562890

LOVE SOLID
ABCDEFGHIJKLMNOPQRSTUVWXYZ1234562890

LOVE STONED
ABCDEFGHIJKLMNOPQRSTUVWXYZ1234562890

T **ORTEM**
ABCDEFGHIJKLMNOPQRSTUVWXYZ1234567890

T **Cruz Swinger**
abcdefghijklmnopqrstuvwxyz1234567890
ABCDEFGHIJKLMNOPQRSTUVWXYZ

T **Windsor**
abcdefghijklmnopqrstuvwxyz1234567890
ABCDEFGHIJKLMNOPQRSTUVWXYZ

T **Windsor Elongated**
abcdefghijklmnopqrstuvwxyz1234567890
ABCDEFGHIJKLMNOPQRSTUVWXYZ

CONTEMPORARY
design
looks back

Greteman Group designers pay tribute to Woodstock, the rock concert held in August 1969 on a piece of farmland in upstate New York that has become an icon of the 1960s youth movement for peace and free love. The artwork in this series of posters named Woof Stock promotes an annual event for the Kansas Humane Society and freely borrows the color palette and patterns, emulating embroidered and tie-dyed clothing, of the turbulent decade.

PROJECT: Woofstock Posters
CLIENT: Kansas Humane Society
DESIGN FIRM: Greteman Group
ART DIRECTOR: Sonia Greteman
DESIGNER/ILLUSTRATOR: Jo Quillin

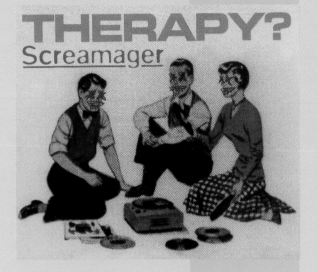

THERAPY?
Screamager

PROJECT: *Therapy?* Screamager CD

CLIENT: A & M Records

DESIGN FIRM: Sunja Park Design

ART DIRECTOR/DESIGNER: Sunja Park

PRINTER: AGI

Think of the early sixties and the image of teenagers happily playing their 45-rpm records comes to mind. That image comes to life on the cover for *Therapy? Screamager* CD, only here, designer Sunja Park decided to mock American teenage idealism by making the friendly group even happier by enhancing their eyes and smiles—not through Photoshop but by seemingly drawing on their faces with a blue ballpoint pen—doodle style. For Park, the 1960s is particularly significant to design. "Everything was possible," Park said. "Designers were finding their voice as a profession."

The year 2000 marked Belyea's twelfth year in business. To commemorate the event, the design firm played off the number twelve by developing a concept hinged on the image of a dozen donuts. "Since the graphic was going on a shirt, a bold, fun graphic was necessary, and it became the perfect opportunity to riff Andy Warhol's Elizabeth Taylor paintings," said Patricia Belyea. "The repetitive graphics directly emulate Warhol's work, while the pastel color palette and straight-forward type reflect the retro style of the sixties."

PROJECT: Belyea 12th Anniversary T-Shirt

CLIENT: Belyea

DESIGN FIRM: Belyea

ART DIRECTOR: Patricia Belyea

DESIGNER/ILLUSTRATOR: Lars Hansen

COPYWRITER: Liz Holland

A dozen years

NO CREAM FILLING

PROJECT: Sierra "It's Jazzy" Press
Event Invitation
CLIENT: Sierra On-Line
DESIGN FIRM: David Lemley Design
ART DIRECTOR: David Lemley
DESIGNERS: David Lemley, Matt Peloza
PRINTER: Ivey Seright

To encourage the media to attend
this Sierra On-Line event, the
company hosted an evening with
a sixties feel—elegant and high-
tone, featuring a jazz band. "It
seemed very 'blue note' with a
twist," said designer David Lemley.
To set the stage, Lemley created
an eye-catching invitation of dark
hosiery-clad legs in pink heels
(playing to the 1960s penchant
for opaque colored stockings).
The invitation was screen printed
with an eighty-five line screen to
capture the look and feel of a six-
ties street poster.

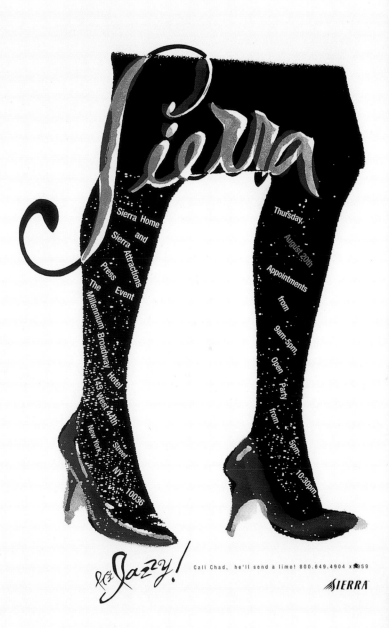

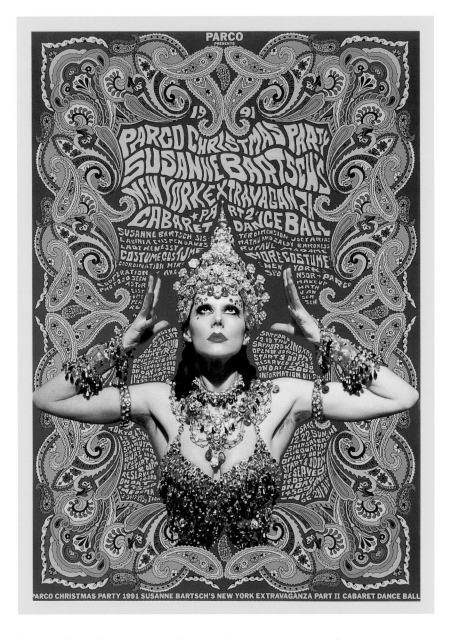

PROJECT: Parco Christmas Party
New York Extravaganza Poster

CLIENT: Parco Co., Ltd.

DESIGN FIRM: Kenzo Izutani Office
Corporation

ARTDIRECTOR/ILLUSTRATOR:
Kenzo Izutani

DESIGNER: Aki Hirai

Designer Kenzo Izutani recreated the psychedelic atmosphere of
the late sixties/early seventies in this dance party's poster with
its paisley-like patterns, rainbow of colors, and curvy, almost
hallucinogenic type treatment.

What period has most influenced your personal style of design?

"The 1970s period has most influenced me (and) the movement of arts and music,"

—*Kenzo Izutani, Kenzo Izutani Office Corporation, who cites Andy Warhol and Higpnosis*

as powerful influences on his style of graphic design.

PROJECT: Groovy Baby Rubber Stamp

CLIENT: Rubber Stampede, Inc.

DESIGN FIRM: Hoffmann Angelic Design

ART DIRECTOR/DESIGNER: Andrea Hoffmann

HAND LETTERING: Ivan Angelic

The phrase "groovy baby" became part of the English language in the 1960s; so much so, it made a comeback some thirty years later as Austin Power's catch phrase. Here, it is replicated as one in a themed set of rubber stamps. The color palette, daisy-style flower pattern, and distinctly sixties typeface all recall the days of "flower power."

The typefaces, explosive color palette, and icons bring to mind the late 1960s and early 1970s when peace signs, Volkswagen vans, and smiley face T-shirts and pins could be found on every street corner while lava lamps provided atmosphere and eight-track tapes revolutionized the music industry. This poster is jam-packed with memories of the era and expertly merged in an artful retrospective collage.

PROJECT: Adapalooza Poster

CLIENT: American Advertising Federation

DESIGN FIRM: Muller & Company

ART DIRECTOR: John Muller

DESIGNER: Dave Swearingen

PHOTOGRAPHER: Ron Berg

COPYWRITER: Pat Piper

This psychedelic poster uses the imagery that marked the advent of the late-1960s and early-1970s drug culture to target parents who came of age during that era. Designers went for accuracy in recreating the look of the decade by juxtaposing an anti-drug message with the typography and fluorescent colors of the period including those hues that are uniquely reflected under a black light. "This was the type of poster every kid in the seventies had," said Marlisa Shapiro of Turkel Schwartz & Partners.

PROJECT: Miami Coalition Bus Shelter Poster
CLIENT: Miami Coalition for a Safe & Drug-Free Community
DESIGN FIRM: Turkel Schwartz & Partners
ART DIRECTOR: David Garcia
ILLUSTRATOR: Dan Gonzalez
COPYWRITER: Dan Gronning

PROJECT: DaGirls T-Shirt Logo
CLIENT: DaGirls
DESIGN FIRM: R2 Design
ART DIRECTORS/DESIGNERS/ILLUSTRATORS:
Lizá Defossez Ramalho, Artur Rebelo

"In the sixties, we can find an expressive generation gap. It's a time when the youth were concerned by political, environmental, and social problems," said Lizá Defossez Ramalho, explaining why the aesthetics of sixties design made it a perfect decade to replicate in this t-shirt logo, which was marketed to young people. The curly, curvy typeface, and particularly the heart image—recognized in a decade where the youth exclaimed, "Make love, not war!" "The typography—because its hand made like a tattoo—has lots of curves that adapt themselves to their own space and form. It feels like something in movement."

What period has most influenced your personal style of design?

"...I like different and contradictory periods and figures of graphic design history. There are so many genial ideas and graphic designs...that can live true history. The most important thing for us is the concept, along with the aesthetics."

—*Lizá Defossez Ramalho, R2 Design, who cites Guillaume Apollinaire as having influenced her style.*

"The sixties were the ultimate party decade, man. And since this was the wrap up party of the century for our client, we were like, inspired. Can you dig it?" said Rik Klingle, art director, of the inspiration for this dynamic party invitation that comes packaged in film tins—appropriate for a "wrap party." "We were inspired by two of the most influential artists of the decade man, Andy Warhol and Roy Lichtenstein. We were trippin' one night and came up with the crazy idea of seeing what would happen if we combined both these cats' styles into one design. The large posterized dot and bright colors of Lichtenstein looked really groovy with Warhol's exploration of a single image as a series. Even though the typestyle chosen was created after this decade, we told you never to trust anyone over thirty, it is very reminiscent of the flower power era."

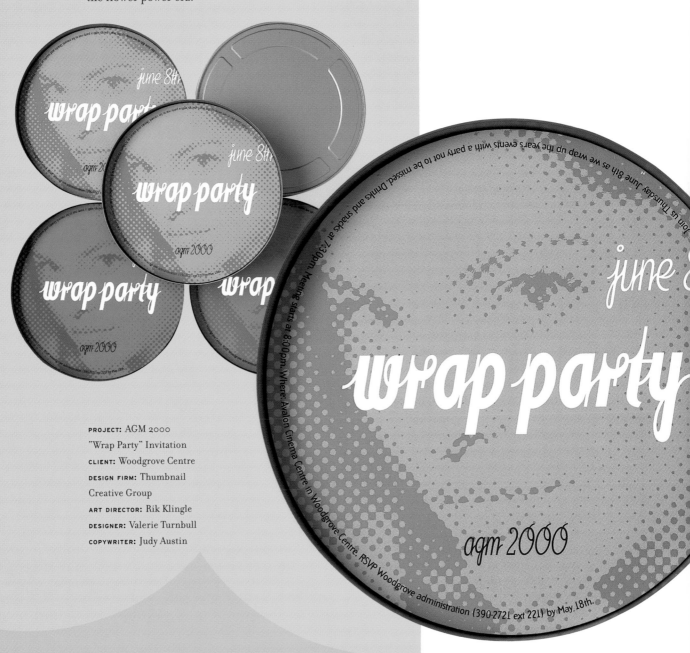

PROJECT: AGM 2000
"Wrap Party" Invitation
CLIENT: Woodgrove Centre
DESIGN FIRM: Thumbnail
Creative Group
ART DIRECTOR: Rik Klingle
DESIGNER: Valerie Turnbull
COPYWRITER: Judy Austin

GRAPHIC TREATMENT OF
mid-century
collectibles

Miami Modernism, an annual show and sale of vintage mid-century modern furnishings and artifacts from the 1900s through 1970s, retained designer John Sayles, an avid collector of nearly everything from the mid-twentieth century, to create the show's poster. What began as a one-poster job was so successful, it turned into an annual project.

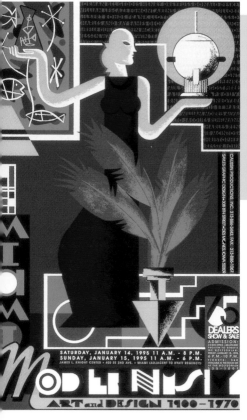

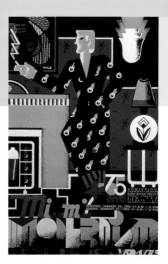

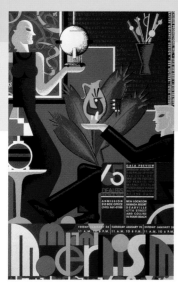

By the show's 1996 and 1997 events, Sayles' posters are highly popular limited-edition works of art. For these two events, Sayles again set both posters in the 1930s-1940s eras, highlighting a gentleman in the first, and joined by a female companion in the second, surrounded by cocktail items, lamps and other items from the era. Both posters, screen-printed in six vibrant colors on a dark green paper stock, display Sayles interpretation of the Art Deco style of the period and demonstrate his avid interest in the era.

Sayles began by putting his love for the era and great designers of the past to work in a poster for the 1995 event, the poster's theme of which he set in the 1930s. "The illustrations clearly represent the best-most highly collectible—artifacts of the era," said Sayles, pointing to his rendering of a special coffee urn, designed by Eliel Saarinen in 1934.

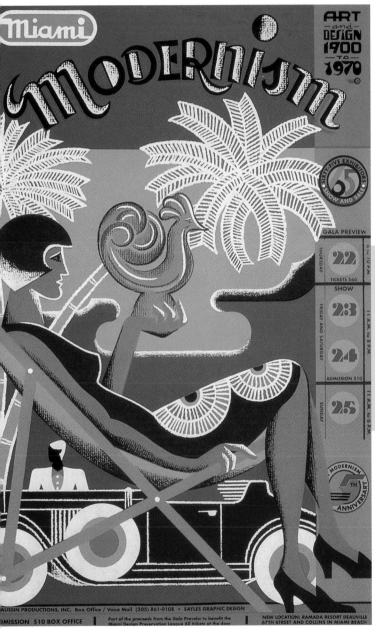

PROJECT: Miami Modernism
Posters 1995-1999
CLIENT: Caussin Productions
ART DIRECTOR/DESIGNER/ILLUSTRATOR:
John Sayles

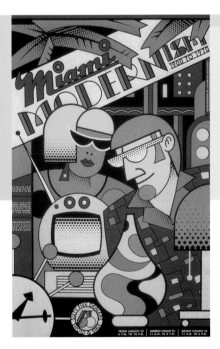

The neon colors and typeface used in the Miami Modernism 1999 poster "are an obvious nod to the sixties and seventies," said Sayles, who honed in on this period to reflect the increasing popularity of vintage artifacts and clothing.

Miami Modernism '98 poster pays homage to the 1950s and its penchant for tropical colors, which coincidentally, also highlighted the event's venue that year, Miami, as well as the 1950s furnishings, which are sought-after collectibles today. "The illustration and type are inspired by the design style of the time with each visual element depicting something that was stylish and modern," said Sayles.

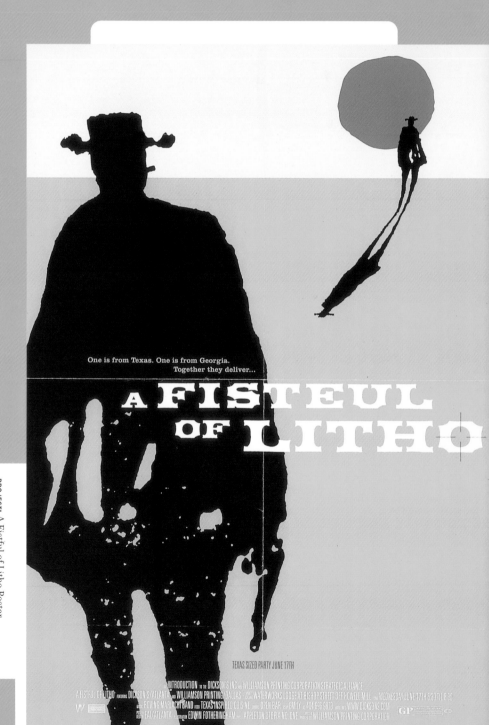

PROJECT: A Fisteul of Litho Poster

CLIENTS: Dickson's, Inc. and Williamson
Printing Corporation

DESIGN FIRM: EAI

CREATIVE DIRECTOR: Phil Hamlett

DESIGNER: Lea Nichols

ILLUSTRATOR: Edward Fotheringham

COPYWRITER: Phil Hamlett

PRINTER: Williamson Printing Corporation

the 1970s

One could stay that the seventies finished off what the late-sixties started. The early part of the decade perpetuated the rebellious standoffs between the youth movements and the "establishment," women and government, and virtually every other organized form of religion and political persuasion. The result was turbulent clashes around the globe. As the decade drew to a close, a calm was beginning to settle over the world. But would it last?

lines head OF THE 1970s

On December 20, 1970, unconfirmed reports came out of Poland that 300 people were killed during clashes between police and demonstrators in Gdansk. That same year, the Roman Catholics and Protestants clashed again in Northern Ireland.

Arab terrorists took hostages during the 1972 Olympics in Munich, Germany. The standoff was finally resolved on September 5, 1972 at the Olympic Village when Arab terrorists were ambushed by German police; all nine hostages were killed, plus a German policeman and five Arab terrorists. Three terrorists were captured.

In 1971, women in Switzerland are granted the right to vote.

In February 1973, the first American POWs from North Vietnam are flown out of the country. Women are allowed on the floor of the London Stock exchange for the first time on March 26, 1973. August 8, 1974 U.S. President Richard Nixon resigned from office and Vice President Gerald Ford is sworn in as president the next day.

The South Vietnamese government surrenders unconditionally to the Vietcong on April 30, 1975. On May 4, 1979, Margaret Thatcher became Britain's first woman Prime Minister.

art
and architecture

October 20, 1973 the Sydney Opera
House, designed by Danish architect
Utzon, opens. It is quickly recognized as
the epitome of modern architecture.

entertainment

The United States celebrated its bicentennial on July 4,
1976. The occasion is marked with colors of red, white,
and blue and all kinds of television programming, prod-
ucts, and events themed to the country's 200th birthday.

"Streaking" becomes a fad and hits its zenith when a
man runs naked across the stage at the Academy
Awards presentation, which is televised worldwide.

The punk era starts in the United Kingdom in 1977 and its
aggressive music and fashions soon spread worldwide.

Soul food and soul music, which originated with African
Americans, becomes popularized and is introduced
cross-culturally.

"Aquarius" and "Hair" top the song charts as do the
Jackson 5's "ABC" and The Beatles' "Let It Be".

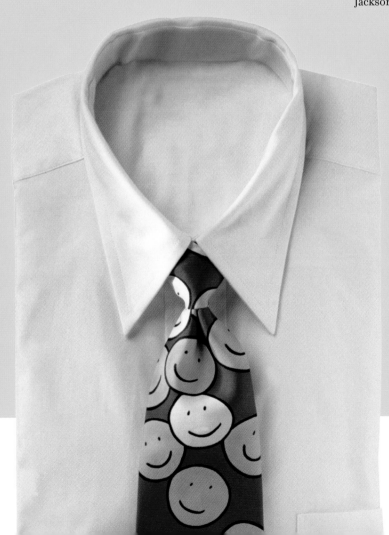

The seventies introduced the ecology movement and the populace turned to earth tones—partly out of their concern for the environment and partly because people were visually exhausted by the frenetic color usage that marked the sixties.

Color
Cues: 1970s

At the same time, technological advancements made even more pigments and dyestuffs available, opening the arena to even more color possibilities. This time, the advances impacted men as much as previous innovations had influenced women. Men gave up their white business shirts and for the first time started wearing colored shirts with coordinating ties. Soft, earthy, desert-inspired colors, inspired by the California lifestyle and climate were also prominent.

However, if one color palette marked the decade, it was that of earth tones, which are remembered today mostly for their use in kitchens, where small and large appliances were given industry-standard names that seventies homeowners shudder at today: avocado (PANTONE 119), harvest gold (PANTONE 129), and burnt orange (PANTONE 152).

As the decade wore on, the colors got deeper, and included bronze as well as various shades of brown (PANTONE 1395, PANTONE 140, PANTONE 4625, and PANTONE 1535), russet (PANTONE 1595), deep red (PANTONE 1797), and dark blue (PANTONE 2955 AND PANTONE 302).

Type Tracker:

1970s

Characteristics

Swash letters, fancy characters that loop under other characters, were popular in the seventies. This trend was prompted by the famous United Airlines advertising campaign — Fly the Friendly Skies—which used Bookman with a twist by incorporating fancy letters in it.

Influences

Trends were established during the 1970s by International Typeface Corporation (ITC), which was formed during the decade and enjoyed its strongest influence in the seventies and early eighties. ITC issued new fonts on a quarterly basis and designers turned to ITC and its magazine, *U&lc*, to see what the newest faces were. All in all, the seventies were a very innovative time with a lot of new typeface designs.

Fonts of the 1970s

The quintessential fonts of the period were ITC Souvenir and ITC Avant Garde Gothic—which were so popular sophisticated designers shunned them for years afterward because they were so associated with the 1970s to the point of overuse. Also popular were ITC Benguiat, ITC Souvenir, ITC Bookman, ITC Tiffany, and Antique Olive.

Typefaces owned and provided by Agfa Monotype.

Fonts you probably own that evoke the era:

T **Bookman**
abcdefghijklmnopqrstuvwxyz1234567890
ABCDEFGHIJKLMNOPQRSTUVWXYZ

T **Benguiat**
abcdefghijklmnopqrstuvwxyz1234567890
ABCDEFGHIJKLMNOPQRSTUVWXYZ

T *Benguiat Book Italic*
abcdefghijklmnopqrstuvwxyz1234567890
ABCDEFGHIJKLMNOPQRSTUVWXYZ

T Avant Garde
abcdefghijklmnopqrstuvwxyz1234567890
ABCDEFGHIJKLMNOPQRSTUVWXYZ

CONTEMPORARY
design
looks back

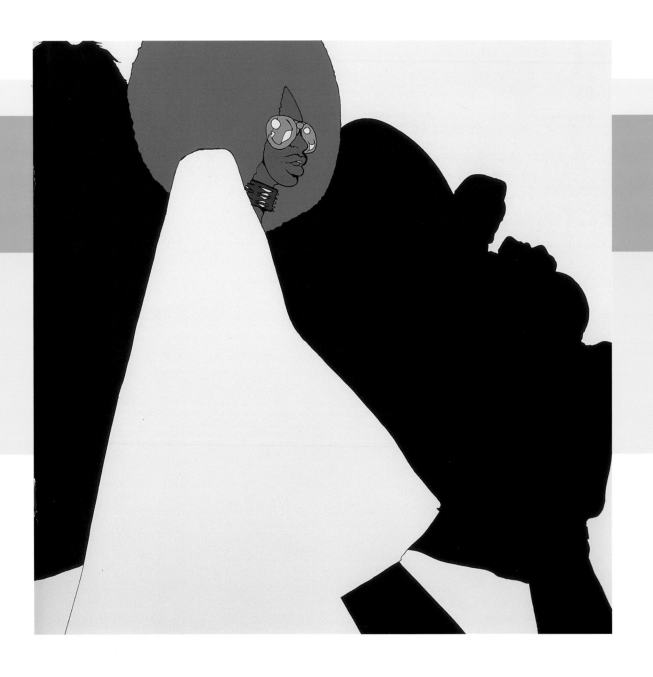

RIAA's 1998 Annual Report is dressed in an explosion of color, which comes as somewhat of a surprise from its funky cover, which is relatively subdued by comparison. Icons of the era—everything from Afros to the hand gesture signifying "peace"—combine with the dynamic color range to shout the seventies. "We wanted to do something funky and the seventies are the home of funk," said designer Neal Ashby. "The bold, bright, unembarrassed colors are clearly seventies with a nineties twist. The style of illustration is clearly 1970s in its line use." While reviewing this annual report, one becomes so engrossed in the era that it is startling to come across discussion of RIAA's work on the Internet.

PROJECT: Recording Industry Association of America (RIAA) Annual Report

CLIENT: Recording Industry Association of America

DESIGN FIRM: Recording Industry Association of America

ART DIRECTOR/DESIGNER: Neal Ashby

ILLUSTRATOR: Kristian Russell

COPYWRITER: Annie Jenkel

PRINTER: Streckel

Rullkötter AGD based the entire identity for Webmaster Tools, including the logo, packaging, CD cover, booklet, and manual on a seventies pop culture icon—not unlike the congenial Ken doll from Mattel®. The look is reinforced with the bold typography and clean lines, which make the identity eye-catching, humorous, and able to communicate its user-friendliness in an instant.

PROJECT: Webmaster Tools Identity

CLIENT: IOK Internet Services
GmbH & Co. KG

DESIGN FIRM: Rullkötter AGD

ART DIRECTOR: Dirk Rullkötter

DESIGNERS: Dirk Rullkötter,
Marco Rullkötter

COPYWRITERS: Rullkötter AGD, IOK
Internet Services GmbH & Co. KG

It is difficult to say the word feelings without it conjuring up memories of the overdone lounge song of the 1970s by the same name, which is exactly the connection designer Stefan Sagmeister was after when he designed the artwork for David Bryne's new CD. Sagmeister used a male doll figure set against a bright color palette to communicate "all sorts of things: commerce in music, pop star as commodity, (and a) nice juxtaposition to the title, *Feelings*," he said. To finish off the theme, Sagmeister even includes a color-coded feelings chart.

PROJECT: David Byrne *Feelings* CD

CLIENT: Luaka Bob, Warner Brothers

DESIGN FIRM: Sagmeister Inc.

ART DIRECTOR: Stefan Sagmeister

DESIGNERS: Stefan Sagmeister, Hjalti Karlsson

PHOTOGRAPHER: Tom Schierlitz

COPYWRITER: David Byrne

PRINTER: Ivy Hill

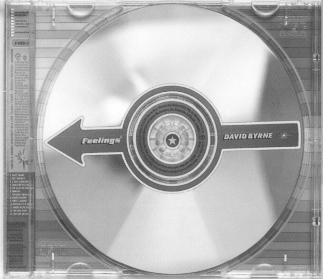

THIEVERY CORPORATION
ABDUCTIONS AND RECONSTRUCTIONS

THIEVERY CORPORATION REMIXES OF STEREOLAB • DAVID BYRNE • PIZZICATO 5
BAABA MAAL • BLACK UHURU • HOOVERPHONIC • ROCKERS HI-FI • THUNDERBALL • URSULA 1000
SLIDE FIVE • WALDECK • AVATARS OF DUB • EDSON CORDEIRO • GUS GUS • URBS 'N CHAOZ

PROJECT: Thievery Corporation
Abductions and Reconstructions CD

CLIENT: ESL Records

DESIGN FIRM: Neal Ashby

ART DIRECTOR/DESIGNER: Neal Ashby

PHOTOGRAPHER: Mike Northrup

PRINTER: Discmakers

"Techno-music, by its nature, has many ties to the seventies,"
said designer Neal Ashby, citing turntables as one example,
is why he chose a 1970s theme for this CD artwork. To
achieve the look he was after he chose the photographic
subject matter—an orb eight-track player—and set it against
a *"Star Wars*-white" background. This is further accented by
the color of the decade—orange, which is one of the warm
earth tones of the decade that became widely used for
perhaps the first time.

STYLUS™

"Stylus Productions specializes in bringing disco music into the new millennium by remixing songs from that period. We chose typographic elements and colors from the seventies to put a *Saturday Night Fever* flair to their logotype," said Kai Braue, pointing to the logo's off-beat, brash colors and the organic shapes that are characteristic of seventies typography.

PROJECT: Stylus Productions Logo
CLIENT: Stylus Productions
DESIGN FIRM: Braue Design
ART DIRECTOR/DESIGNER/ILLUSTRATOR:
Kai Braue

Computers were rare items in the 1970s, but when you could find one, it typically featured ASCII artwork, which was limited to two colors with a microchip texture, all of which was presented in an electronic panel style design. It is this look that Gustavo Machado imitated when he created his Web site, which promotes the firm's expertise in digital, new media projects.

PROJECT: Gustavo Machado Studio Web Site
www.gustavo-machado.com/english
CLIENT: Gustavo Machado Studio
DESIGN FIRM: Gustavo Machado Studio
ART DIRECTOR/DESIGNER/ILLUSTRATOR:
Gustavo Machado
COPYWRITER: Gustavo Machado

OPPOSITE PAGE

PROJECT: London Today...Melbourne
Tomorrow Poster
CLIENT: Immigration Museum - Melbourne,
Victoria, Australia
DESIGN FIRM: Beattie Vass Design Pty. Ltd.
ART DIRECTORS: Tom Beattie, Giota Vass
ILLUSTRATOR: Bill Wood (Bill Wood Illustration)

The timeliness of flight between London and Melbourne
is highlighted in this seventies-inspired poster, when
such travel became possible. Aside from the obligatory sky
blue, illustrator Bill Wood recreated the 1970s era using
acrylic and gouache in shades of gold and russet.

PROJECT: A Fistful of Litho Poster
CLIENTS: Dickson's, Inc. and Williamson
Printing Corporation
DESIGN FIRM: EAI
CREATIVE DIRECTOR: Phil Hamlett
DESIGNER: Lea Nichols
ILLUSTRATOR: Edward Fotheringham
COPYWRITER: Phil Hamlett
PRINTER: Williamson Printing Corporation

"One is from Georgia. One is from Texas" the poster's copy extols, setting the scene for a
party announcing the collaboration of Dickson's, Inc. and Williamson Printing Corporation-
two lone lithographers fighting for high-quality printing. The poster plays to the seventies
penchant for what was dubbed, "spaghetti westerns," a film genre inspired by such movies
as *A Fistful of Dollars* and *The Good, The Bad, and The Ugly*. To recreate the seventies movie
poster look, EAI designers incorporated woodblock type, flat art, and the warm shades of
the 1970s color palette.

100 Years OF *GOOD HOUSEKEEPING*

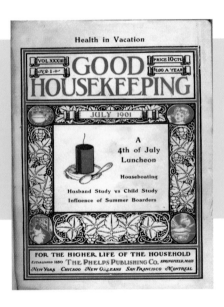

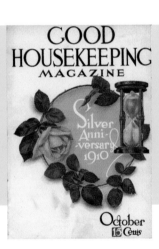

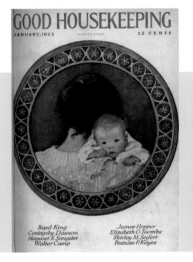

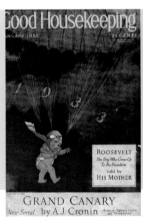

Good Housekeeping, a magazine crafted to the American homemaker, began publishing in 1880 and targeted its editorial to "the higher life of the household." Over its 120 years, it has evolved and adapted to the changing role of women and specifically, their roles as wives and mothers or it, like many of its rivals, would have fallen by the wayside long ago, due to lackluster circulation figures.

What is the secret to *Good Housekeeping*'s success? Quite simply, its keen ability to change—visually and editorially—to keep pace with the rapidly changing, growing, and expanding role of women. In its early years, the magazine's cover relied heavily on illustration and focused primarily on women and their responsibilities to their husbands and children. By the 1920s and 1930s, the magazine supplemented its how-to's by adding fiction by noted writers to the mix, while its covers still paid tribute to the joys of motherhood; illustration remained key to the magazine's cover design.

By July 1943, its cover, like many U.S. magazines, focused on patriotic themes to inspire women on the home front participating in the war effort. In the 1950s, home and family once again took center stage, visually on the magazine's cover and editorially.

We see a new trend beginning in 1960. Though the cover is quite innocent in contrast to cover designs of the late-1960s—stories on celebrities begin being touted as the primary story and covers began using more photography in lieu of illustration. By the seventies, celebrities were standard fixtures of *Good Housekeeping*'s cover design. Reading about the joys, trials, and tribulations of well-known women wrestling with careers and family sold magazines. The trend to using celebrities from the entertainment field as well as the political arena and photographic covers continues as the magazine embarks on tailoring covers to women in the year 2000. However, that is not to say the trend is expected to continue well into the 2000s, according to Ellen Levine, *Good Housekeeping*, editor-in-chief.

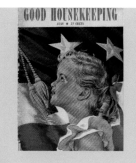 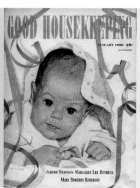 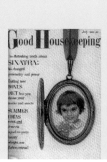 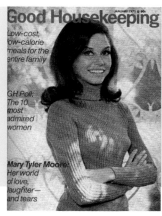

"We're on the cusp of change now. We're not creating any new celebrities, especially among women," Levine said. What the new trend will be, Levine isn't sure, but she is certain of one thing—*Good Housekeeping* will adapt to the new readership. "Magazines don't lead readers; readers lead magazines. If you don't change, you don't survive. It is magazine Darwinism.

"Magazines are a very good mirror of what the population wants to know about," added Levine. "If I wanted to be very nostalgic and do a hugely illustrated cover today, it would flop. People want charming illustrations on their greeting cards, not on their reading material."

What will the graphic trends be on magazine covers in the decades to come? Right now, no one is guessing. The only certainty is change.

Home | Autostadt | Services | Shop | AutostadtCard

Dürfen wir Sie in eine neue Welt en

Audi tritt mit Vorsprung durch Technik, mit schlichter E
Zeitlosigkeit im Design als eine Marke für moderne, ver
Menschen auf. Ihnen geht Persönlichkeit über Status. Die
Besucher ein zu einem multimedialen Erlebnisgang durch

Gebäudeplan | ▶ Gehe zu KundenCenter | Audi Pavillon

MESSEN ZOOM — ▶ +

Navigationshilfe

PROJECT: Autostadt Web Site

CLIENT: Autostadt GmbH

DESIGN FIRM: Scholz & Volkmer
Intermediales Design, GmbH

ART DIRECTOR: Anette Scholz

DESIGNER: Susanne Schwalm

COPYWRITERS: Silke Gentzsch, M. Faerber,
M. Schmiedt, Thorsten Kraus,
Matthias Frey, M. Hermanni

the 1980s and 90s

As unlikely as it sounds, the first twenty years of the century and the last two decades that closed out the millennium have much in common. While seemingly from two different worlds, the two periods experienced lifestyle-changing innovations in technology that totally transformed everyday life.

There were no cars at the beginning of the 1900s, but in a scant twenty years, the Model-T was the preferred mode of transportation—effectively putting the old horse n' buggy out of commission.

Similarly in 1980, offices were populated with typewriters—the cream of the crop being the IBM Selectric. Next to each typewriter was a bottle of correction fluid and carbon paper. Fax machines —if an office had one—were used primarily for emergencies, certainly not everyday correspondence. By the mid-1980s, WANG computers were making inroads into leading-edge offices and intrepid office workers gradually learned the ins and outs of peering into a black screen with

its display of neon green type. However, in less than twenty years, computers had revolutionized the office and the home—effectively putting the typewriter, carbon paper, and correction fluid out of commission.

Electricity, telephones, refrigeration, airplanes—each invention radically impacted life in the early century. Likewise, cellular telephones, the Internet, computer chips, answering machines, and E-mail dramatically changed how we lived in the latter part of the century.

head
lines OF THE 1980s and 90s

December 8, 1980-John Lennon, a member of the Beatles pop group, is shot dead in New York. The next year, on March 30, 1981, U.S. President Reagan is shot and wounded outside the Hilton Hotel in Washington. Then, on May 13, 1981, Pope John Paul II is shot and seriously injured in St. Peter's Square, Rome, by a Turkish terrorist.

A fairy tale wedding when the Prince of Wales marries Lady Diana Spencer July 29, 1981 and the entire world tunes in their televisions to watch the festivities.

On November 9, 1989, the border separating Western from Eastern Germany was effectively opened. This date is recognized officially as the fall of the Berlin Wall.

Retired football great, O.J. Simpson's wife, Nicole Brown, and her friend, Ronald Goldman, are brutally slain outside her home in June 1994. Simpson is arrested and tried for the murders in what was called, "The Trial of the Century."

In August 1996, the world awoke to the startling headlines that Princess Diana was killed in a car crash in a Paris tunnel. For the next several days, television and cable networks provided 24-hour coverage on the crash, the Royals' reaction to her death, and the funeral.

Beginning in 1998 and climbing to a frenzy of headlines in 1999, are scare stories and tips for preparing for the impending global disaster predicted to strike at midnight on January 1, 2000, now being referred to by the techno-moniker Y2K.

The late 1990s are bustling with news and controversy surrounding the changeover to the Euro, the new currency uniting all of Europe.

technology and science

Computers are introduced in the 1980s and grow in practicality and popularity to be a common office and household appliance by the early 1990s.

entertainment

The 1980s are marked by a glut of punk rock, rock music with outrageous, often obscene words, accompanied by equally outrageous behavior by its performers.

In 1982, actress Jane Fonda released the *Jane Fonda: Workout*, the first of many best-selling fitness videos that have been credited with jumpstarting a global exercise craze.

James Cameron's retelling of the fateful voyage of the *Titanic* broke all box office records worldwide when it was released December 19, 1997.

Situation comedies are king on television and among the highest-rated programs are *The Cosby Show*, *Sixty Minutes*, *Cheers*, *Friends*, and *ER*.

A new word was coined—Yuppie—as young, upwardly mobile professionals with a love for the expensive cars, clothing, and watches that their sizeable disposable income could buy, created an entirely new market. As a result, television shows catering to the wealthy— powerful men and well-dressed women in shoulder pads—gained prominence such as *Dallas* and *Dynasty*.

The world gets a new Internet language in 1998 when such new words as E-mail, E-tailing, E-commerce, E-banking, and virtually any business with an E in front of its name becomes a fast climber on the stock market.

December 1999 ushers in the biggest holiday retailing blitz ever, dominated by new virtual Internet stores, which predicted that most consumers would do their holiday shopping on the Web.

By the 1980s, the buying public had had their fill of earth tones and the colors were no longer selling—in anything—clothing or appliances. New color palettes emerged, but splintered into two groups: Those favoring mauve (PANTONE 500), teal (PANTONE 563), and gray (PANTONE 429), which quickly became the principal neutral color of the decade; and those who leaned toward the Nordic influence, a palette featuring an array of cool blues (PANTONE 279, PANTONE 291) and blue-greens (PANTONE 313, PANTONE 319, PANTONE 3272).

Color 1980s
Cues:

These colors remained popular until the mid-eighties—when people had been mauved, tealed and grayed to death and demanded new colors. It seems that the lifecycle of color palettes was decreasing.

During this time, the women's movement was on the rise and fashion was all over the place—skirts were long and short; women stopped following fashion edicts and wore what looked best on them. The trend carried into color as well and people thought of color palettes in terms of what they liked. The result was a backlash on the idea of a person being color-printed, a trend that gained prominence in the seventies and pigeonholed a person as a particular "season," which in turn, determined the colors they should wear. Instead, consumers began recognizing the psychological aspects of color.

There was less dogma and more freedom and color choices were now based on the question: How does it make you feel?

Arising out of this trend was the popularity of colors born of the American West (also called Santa Fe colors) and those inspired by the film *Out of Africa*—namely peach (PANTONE 1565), pink and coral (PANTONE 176), turquoise (PANTONE 2975), sand (PANTONE 727), ivory (PANTONE 9140), and lavender (PANTONE 263). These colors, previously thought to be exclusively feminine, permeated into men's fashion and accessories as well, a trend that was globalized in such television shows as *Miami Vice*, which popularized the Florida look. During the mid- to late-1980s, men could be seen sporting colors they had never worn before.

Amid all the pastels, black made a resurgence (PANTONE PROCESS BLACK). In the U.S., the Reagans were in the White House, and due in part of Nancy Reagan's influence, the pair brought back the glamour of black. Black limousines and black taffeta defined grandeur and luxury. Black's new caché translated to interior design as well, where it came to be associated with the high-tech look. Chrome, steel (PANTONE 8002) and gray (PANTONE WARM GRAY) were accented with black to capture the newest look in modern, up-to-date kitchen technology. It became elegant to have a black phone again, which had not been popular since color invaded home appliances in the 1950s and 1960s.

The popularity of *Star Wars*' Darth Vader also had a lot to do with making black elegant and sexy and a new descriptive for black was born: tough chic.

Black (PANTONE PROCESS BLACK) was popular in the late-1980s and continued to be so into the nineties, but for other reasons. Now it was popular because the economy took a nosedive, and in such times, black tends to rise above other colors as the shade of preference. Bright colors also went away, while environmentalism was popularized. Beige, off-white, and ivory (PANTONE 454, PANTONE 9161, PANTONE 4685, AND PANTONE 9061) gained favor for their no-color look and perfectly showed-off natural cottons and showed up as white, almond, and stainless steel appliances.

Color Cues: 1990s

But the decade was not without its hallmark color. If one color had to be chosen to define the decade it would be hunter green (PANTONE 3305). Green was symbolic of nature and even the word green entered into our speech patterns—in phraseology that harkened to the environment and ecology as a whole.

By the middle part of the decade, the economy started to spike, so color came back into public life in full-force. While colors had never disappeared entirely, they had become less saturated, and now they re-emerged with a different hue. Between 1995 and 1997, yellow-green, chartreuse, and lime green (PANTONE 389) debuted in plastics and in clothing. Brights came back in every color form from yellow (PANTONE 107), orange (PANTONE 170), and red (PANTONE RED 032) to violet (PANTONE 2592), periwinkle (PANTONE 2725), and pink (PANTONE 211). During this time, green (PANTONE GREEN) appeared in numerous incarnations and remained popular, as did black, which never lost its power and showed no signs of disappearing.

As the turn-of-the-century approached, a new color appeared on the scene that was to become associated with the year 2000. It was a shade aptly named, millennium blue, a hue, which was forecasted to be *the* color that would define the early twenty-first century.

1980s

AND

1990s

Type
Tracker:

Influences

Prior to 1985 and the advent of desktop publishing, the control of how typefaces looked and were fashioned was held in a few hands, primarily the large foundries, a couple of influential designers, and companies like International Typeface Corporation (ITC).

When desktop publishing boomed, boutique type foundries popped up and all different styles of fonts became available and there was a lot of experimentation, as well as a lot of revivals. Companies like T26, Adobe, Font Bureau, and many individual designers influenced typeface design during the latter part of the twentieth century. There was really no single influence on type during this period.

Characteristics

Because of the proliferation of type houses during the last twenty years of the 1900s, it is difficult to pin down one or two characteristics that exemplify type of that period. Wildly experimental, alternative designs were created and competed successfully with retro faces and revivals of old standbys. Three trends emerged during the twenty-year span between 1980 and 1999. First, as mentioned, there were a lot of alternative typestyles and experimental type treatments as evidenced by such fonts as Space Kid, Synchro, and Handwrite Inkblot. Calligraphic typefaces were also popular as evidenced by the wide use of ITC Humana and the light-handed Papyrus. Finally, retro typefaces that allowed designers to use new, cutting edge fonts to replicate another time also boomed. Some of the more popular fonts of this style include Mojo, which conjures up images of the 1970s, Martini at Joe's, replicating the 1950's modern style, and Bertram, which is a throwback to the 1940s.

Typefaces owned and provided by Agfa Monotype.

A few fonts showing the diverse trends of the 1980s and 1990s include:

BERTRAM

ABCDEFGHIJKLMNOPQRSTUVWXYZ1234567890

Handwrite Inkblot

abcdefghijklmnopqrstuvwxyz1234567890
ABCDEFGHIJKLMNOPQRSTUVWXYZ

Humana Serif Bold

abcdefghijklmnopqrstuvwxyz1234567890
ABCDEFGHIJKLMNOPQRSTUVWXYZ

Humana Serif Light

abcdefghijklmnopqrstuvwxyz1234567890
ABCDEFGHIJKLMNOPQRSTUVWXYZ

MARTINI AT JOES

ABCDEFGHIJKLMNOPQRSTUVWXYZ1234567890

Papyrus

abcdefghijklmnopqrstuvwxyz1234567890
ABCDEFGHIJKLMNOPQRSTUVWXYZ

⊔⊓⊐⊓⊓ ⊥⊦⊡

⊐⊓⊓⊓⊓⊓⊐⊓⊩⊣⊩⊏⊒⊒⊐⊓⊐⊓⊐⊓⊔⊣⊂⊂⊏⊠⊣⊠⊢⊣⊒⊢⊞⊳⊡⊔⊐⊡⊔⊐⊐

SYNCHRO

ABCDEFGHIJKLMNOPQRSTUVWXYZ1234567890

SYNCHRO REVERSED

ABCDEFGHIJKLMNOPQRSTUVWXYZ1234567890

CONTEMPORARY
design
looks back

Designers created the Thango logo in 1995 to be very current and reflect the design characteristics of the time. The result: an eclectic mix of typography, combined with digital media, and according to Pepe Gimeno, "The deconstructive concept of the composition."

PROJECT: Thango Logo
CLIENT: Thango
DESIGN FIRM: Pepe Gimeno
- Proyecto Gráfico
ART DIRECTOR: Pepe Gimeno
DESIGNER: Ana Iranzo
PRINTER: Sancho Artes Gráficas

Bio
Awards
Portfolio
Contact

PROJECT: Gustavo Machado
Studio CD-Rom

CLIENT: Gustavo Machado Studio

DESIGN FIRM: Gustavo Machado Studio

ART DIRECTOR/DESIGNER/ILLUSTRATOR:
Gustavo Machado

PHOTOGRAPHER: Marcia Bernardino

COPYWRITER: Gustavo Machado

Gustavo Machado's design firm in Brazil specializes in high-tech, new media projects, so to promote his work on a new CD-Rom, he chose to use imagery from 1980 computer technology, including the kind of pixelization and low-resolution geometric shapes that were typical of Atari-style microcomputers of this period. When one is reminded of what computer technology was like in the eighties, it becomes all the more remarkable of what is possible today.

Brainstore, a Brazilian firm, wanted to communicate that it was prepared for the 21st century, so Gustavo Machado's team went to work creating a Web site where "three-dimensional images, (a) surreal compositon, light painting, and other recent elements combine to evoke modernism and technology," said Machado.

PROJECT: Brainstore Web Site

CLIENT: Brainstore

DESIGN FIRM: Gustavo Machado Studio

ART DIRECTOR/DESIGNER/ILLUSTRATOR:
Gustavo Machado

COPYWRITER: Gustavo Machado

What period has most influenced your personal style of design?

"The twenties. My work is based on research and experimentation. Art movements in this period like Dada, Constructivism, and Futurism emulated these issues." — *Gustavo Machado, Gustavo Machado Studio*

PROJECT: New York Botanical Garden Landscape
Architecture and Signage
CLIENT: New York Botanical Garden
DESIGN FIRM: Selbert Perkins Design Collaborative
CREATIVE DIRECTOR: Clifford Selbert
DESIGNERS: Clifford Selbert,
Robin Perkins, Linda Kondo
PHOTOGRAPHER: Anton Grassl

Selbert Perkins Design joined forces with the architectural
firm of Hardy, Holzman, Pfeiffer to renovate the New York
Botanical Garden. The design team developed a system of
environmental communications by adapting botanical
places from the Garden's archives into a new collection of
floral illustrations, which were applied to banners, inter-
pretive exhibits, wayfinding and information kiosks, maps,
signs, and printed communication. The final outcome—in
total—reflects much of the return to nature and a simpler
lifestyle that prevailed in the 1990s. In the U.S., the
nineties was a decade when home and garden guru,
Martha Stewart, built a marketing empire with her myriad
do-it-yourself tips, and new cable networks, like *Home &
Garden TV*, popped up on television channels everywhere.
To paraphrase Martha Stewart, the botanical garden look—
it's a nineties thing.

The images that run through this CD-Rom possess clean lines, sleek photography—elements that have, thankfully, replaced overused, cluttered layouts of the early days of interactive CD-Roms when the technology was new and designers wanted to integrate all the tools at their disposal. It also features an eclectic blend of graphics that have only become possible through 1990s computer technology. Juxtaposing high-tech images of upscale German engineered automobiles against a simplistic child's drawing is not only acceptable, but also visually appealing.

PROJECT: Mercedes-Benz A-Class CD-Rom

CLIENT: Daimler Chrysler

DESIGN FIRM: Scholz & Volkmer
Intermediales Design, GmbH

ART DIRECTORS: Anette Scholz,
Michael Volkmer

DESIGNERS: Holger Hirth, Nico Gerlach,
Britta Vogt, M. Hermanni, Denise
Wasserburger, Irmgaar Weigl, M. Kraft,
Thorsten Kraus

PROJECT: Autostadt Web Site

CLIENT: Autostadt GmbH

DESIGN FIRM: Scholz & Volkmer
Intermediales Design, GmbH

ART DIRECTOR: Anette Scholz

DESIGNER: Susanne Schwalm

COPYWRITERS: Silke Gentzsch,
M. Faerber, M. Schmiedt,
Thorsten Kraus, Matthias Frey,
M. Hermanni

This Web site is cleanly interactive, offering a choice of
viewing in German or English, with a spare, uncluttered
layout, built on a grid pattern of colored rectangles that
presents a lot of information without any fuss. Even the
shopping page, which typically falls prey to too much
information presented in too small a space, is much like
a simple catalog page—easy to view and buy.

Interestingly, this 1990s logo and identity incorporate aspects of the 1950s in its design—a trend that became widely popular in graphic design in the late twentieth century, known as "retro." As the millennium approached, increasingly companies wanted to look back. In the nostalgia of past decades, designers found the intrinsic characteristics they wanted and needed to associate with their clients' images. Consequently, 1990s design is often not as characteristic of the 1990s per se as it is of another decade with nineties overtones. Kai Braue describes this design as "neo-retro because it reflects the 1950s with a sleek futuristic touch. The strange mix of advertising typography from the fifties, mixed with metallic colors and a unique kind of paper (Countryside Moonlight) in addition to modern black-and-white photography" creates the illusion.

PROJECT: Starke Veranstaltungen Identity

CLIENT: Starke Veranstaltungen

DESIGN FIRM: Braue Design

ART DIRECTOR: Kai Braue

DESIGNERS/ILLUSTRATORS/COPYWRITERS:

Kai Braue, Marcel Robbers

PHOTOGRAPHY: Frea Eden

PRINTER: Druckerei Riemann

Contributors

Addison
79 5th Avenue, 6th Floor
New York, NY 10003
www.addison.com

Anvil Graphic Design
2611 Broadway
Redwood City, CA 94062
www.hitanvil.com

Baumann & Baumann, Büro für Gestaltung
Taubentalstrasse 4/1
Schwäbisch Gmünd 73525
Germany
www.baumannandbaumann.com

Beattie Vass Design Pty Ltd.
18 Willis Street
Richmond, Victoria
Australia
www.bvdesign.com.au

Belyea
1809 7th Avenue, Suite 1250
Seattle, WA 98101
www.belyea.com

Bill Wood Illustration
24 Gould Street
Burwood, Victoria 3125
Australia
www.illustration.com.au

Braue Design
Eiswerkestrasse 8
27572 Bremerhaven
Germany
www.brauedesign.de

Chris Rooney Illustration/Design
639 Castro Street
San Francisco, CA 94114-2506
www.looneyrooney.com

CPd - Chris Perks Design
333 Flinders Lane, 2nd Floor
Melbourne, Victoria 3000
Australia
www.cpdtotal.com.au

David Lemley Design
8 Boston Street, #11
Seattle, WA 98109
www.lemleydesign.com

The Design Group
Cityplaza 3, 6th Fl
14 Tai Koo Wan Road
Hong Kong, China

EAI
887 W. Marietta Street, NW
Suite J-101
Atlanta, GA 30318
www.eai-atl.com

Eymer Design, Inc.
25 Dry Dock Avenue
Boston, MA 02210
www.eymer.com

Fossil
2280 N Greenville
Richardson, TX 75082
www.fossil.com

Good Housekeeping
959 8th Avenue
New York, NY 10019

GSD&M
828 West 6th Street
Austin, TX 78703

Graif Design, Inc.
165 E. Highway CC
Nixa, MO 65714
www.graifdesign.com

Greenfield/Belser Ltd.
1818 N. Street N.W., Suite 225
Washington, DC 20036
www.gbltd.com

Greteman Group
1425 E. Douglas
Wichita, KS 67214
www.gretemangroup.com

Gustavo Machado Studio
Rua Itu, 234192
Campinas, SP 13025-340
Brazil
www.gustavo-machado.com/english

HGV Design Consultants
46A Rosebery Avenue
London EC1R 4RP
United Kingdom
Email: design@HGV.co.uk

Heart Times Coffee Cup Equals Lighting
8538 Hollywood Blvd.
Los Angeles, CA 90069

Hoffmann Angelic Design
317-1675 Martin Drive
Surrey, BC V4A 6E2
Canada
Email: Hoffmann_angelic@telus.net

Hornall Anderson Design Works, Inc.
1008 Western Avenue
Suite 600
Seattle, WA 98104
www.hadw.com

Johnny V Design
2702 Dartmouth Road, Apt. #6
Alexandria, VA 22314
www.funkfoto.com

Kenzo Izutani Office Corporation
1-24-19 Fukasawa
Setagaya-Ku
Tokyo 158-0081
Japan
http://home.att.net.jp/orange/izutanix

Kim Baer Design Associates
807 Navy Street
Santa Monica, CA 90405
www.kbda.com

Louis London
6665 Delmar Blvd., Suite 300
St. Louis, MO 63130

Lowercase, Inc.
213 West Institute Place, Suite 311
Chicago, IL 60610
www.lowercaseinc.com

Michael Doret Graphic Design
6545 Cahuenga Terrace
Hollywood, CA 90068
www.michaeldoret.com

Mike Quon/Designation Inc.
53 Spring Street
New York, NY 10012
www.mikequondesign.com

National Broadcasting Company, Inc.
30 Rockefeller Plaza
New York, NY 10112

Muller & Company
4739 Belleview
Kansas City, MO 64112
www.mullerco.com

Neal Ashby
1330 Connecticut Ave., N.W.
Suite 300
Washington, DC 20036
Email: nashby@riaa.com

neo design
1048 Potomac Street, NW
Washington, DC 20007
www.neo-design.com

Palazzolo Design Studio
6410 Knapp
Ada, MI 49301
www.palazzolodesignstudio.com

The Partnership
512 Means Street, #400
Atlanta, GA 30318
Email: A-dusenberry@thepartnership.com

Paul Rogers Studio
12 S. Fair Oaks, #208
Pasadena, CA 91109
Email: rvhstudio@aol.com

Pepe Gimeno - Proyecto Gráfico
C/ Cadirers, s/n - Pol. d'Obradors
E-46110 Godella
Valencia, Spain
Email: gimeno@ctv.es

Plazm Media, Inc.
P.O. Box 2863
Portland, OR 97208-2853
Email: design@plazm.com

The Pushpin Group Inc.
18 East 16th Street, 7th Floor
New York, NY 10003
www.pushpininc.com

R.M. Hendrix Design Company
P.O. Box 2128
Chattanooga, TN 37409
www.hendrixdesign.com

Recording Industry Association of America
1330 Connecticut Ave., NW, Suite 300
Washington, DC 20036
www.riaa.com

R2 Design
Prc. D. Nuno Àlvares Pereira, 20 5º FQ
4450-218 Matosinhos
Portugal
www.rdois.com

Rullkötter AGD
Kleines Heenfeld 19
D-32278 Kirchlengern
Germany
www.rullkoetter.de

Sagmeister Inc.
222 West 14 Street
New York, NY 10011
Email: ssagmeiste@aol.com

Sayles Graphic Design
3701 Beaver Avenue
Des Moines, IA 50310
Email: Sayles@saylesdesign.com

Scholz & Volkmer Intermediales Design,
GmbH
Schwalbacher Strasse 76
D-65783 Wiesbaden
Germany
www.s-v.de

Selbert Perkins Design Collaborative
2067 Massachusetts Avenue
Cambridge, MA 02138
Email: shaddad@spdeast.com

Segura Inc.
1110 N. Milwaukee Avenue
Chicago, IL 60622
www.segura-inc.com

Shields Design
415 E. Olive Avenue
Fresno, CA 93728
www.shieldsdesign.com

Smart Works Pty. Ltd.
113 Ferrars Street
Southbank, Victoria 3006
Australia
www.smartworks.com.au

Studio Flux
3515 Aldrich Avenue, S., No. 4
Minneapolis, MN 55408
Telephone: (612) 824-0308

Sunja Park Design
2116 Roselin Place
Los Angeles, CA 90039
www.sunjadesign.com

Tau Diseño S.A.
Felipe IV, 8. 2º izda.
28014 Madrid
Spain
Email: spain@taudesign.com

Thumbnail Creative Group
#301 - One Alexander Street
Vancouver, BC
Canada V6A 1B2
Email: rik@thumnailcreative.com

Turkel Schwartz & Partners
2871 Oak Avenue
Coconut Grove, FL 33133
www.braindarts.com

Viva Dolan Communications
and Design Inc.
99 Crown's Lane, 5th Floor
Toronto, ON M5R 3P4
Canada
www.vivadolan.com

Wasserman & Partners Advertising Inc.
1020 Mainland Street, Suite 160
Vancouver, BC V6B 2T 4
Canada
www.wasserman-partners.com

Beal, George. *20th Century Timeline*, New York: Crescent Books, 1985.

Eiseman, Leatrice. *Colors for Your Every Mood*. Capital Books, Sterling, VA, 1999.

Eiseman, Leatrice. *The Pantone Book of Communicating with Color*. Graphix Press, LTD. distributed by North Lights Books, Cincinnati, Ohio, 2000.

BIBLIOGRAPHY

about the author

Cheryl Dangel Cullen is a writer and public relations consultant specializing in the graphic arts industry. She is the author of *The Best of Annual Report Design*, *Direct Response Graphics*, *Large Graphics—Design Innovation for Oversized Spaces*, *Small Graphics—Design Innovation for Limited Spaces*, and co-author of *Global Graphics: Color—Designing with Color for an International Market* and *Global Graphics: Symbols—Designing with Symbols for an International Market*. Cullen Communications, a firm she founded in 1993, provides public relations programs for clients in the graphic arts, printing, and paper industries. She is also an avid collector of *Gone With the Wind* memorabilia and ephemera.